Women in Medicine

Women in Medicine

A CELEBRATION OF THEIR WORK

Ted Grant & Sandy Carter

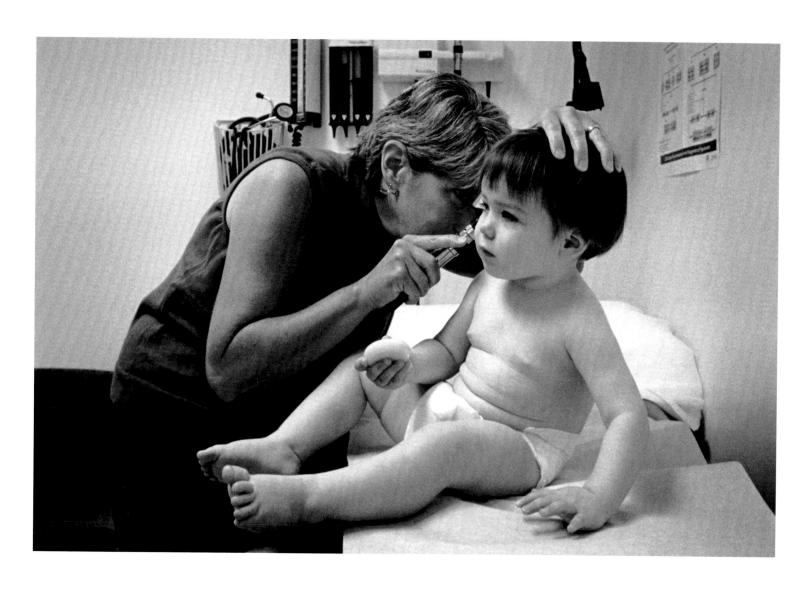

FIREFLY BOOKS

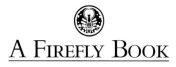

A FIREFLY BOOK

Published by Firefly Books Ltd. 2004

First printing

Publisher Cataloging-in-Publication Data (U.S.)

Grant, Ted.
 Women in medicine : a celebration of their work /
Ted Grant and Sandy Carter. –1st ed.
[192] p. : photos. ; cm.

Includes bibliographical references and index.
ISBN 1-55297-906-7

4142

1. Women in medicine – History – 20th century — Pictorial works. I. Carter, Sandy. II. Title.

610. /922 B 22 R692.G73 2004

National Library of Canada Cataloguing in Publication

Grant, Ted, 1929-
 Women in medicine : a celebration of their work /
Ted Grant and Sandy Carter.

Includes bibliographical references and index.
ISBN 1-55297-906-7

1. Women in medicine. I. Carter, Sandy, 1949- II. Title.

R692.G73 2004 610.69'082 C2004-900411-5

Published in the United States in 2004 by
Firefly Books (U.S.) Inc.
P.O. Box 1338, Ellicott Station
Buffalo, New York 14205

Published in Canada in 2004 by
Firefly Books Ltd.
66 Leek Crescent
Richmond Hill
Ontario L4B 1H1

Printed in Canada by Friesens, Altona, Manitoba

The Publisher acknowledges the financial support of the Government of Canada through the Book Publishing Industry Development Program for its publishing activities.

We dedicate this book to all the remarkable women in medicine.

With special thanks for their continued love and support to Irene Grant,

Krista Feeley and Jennifer Branov.

TED GRANT & SANDY CARTER

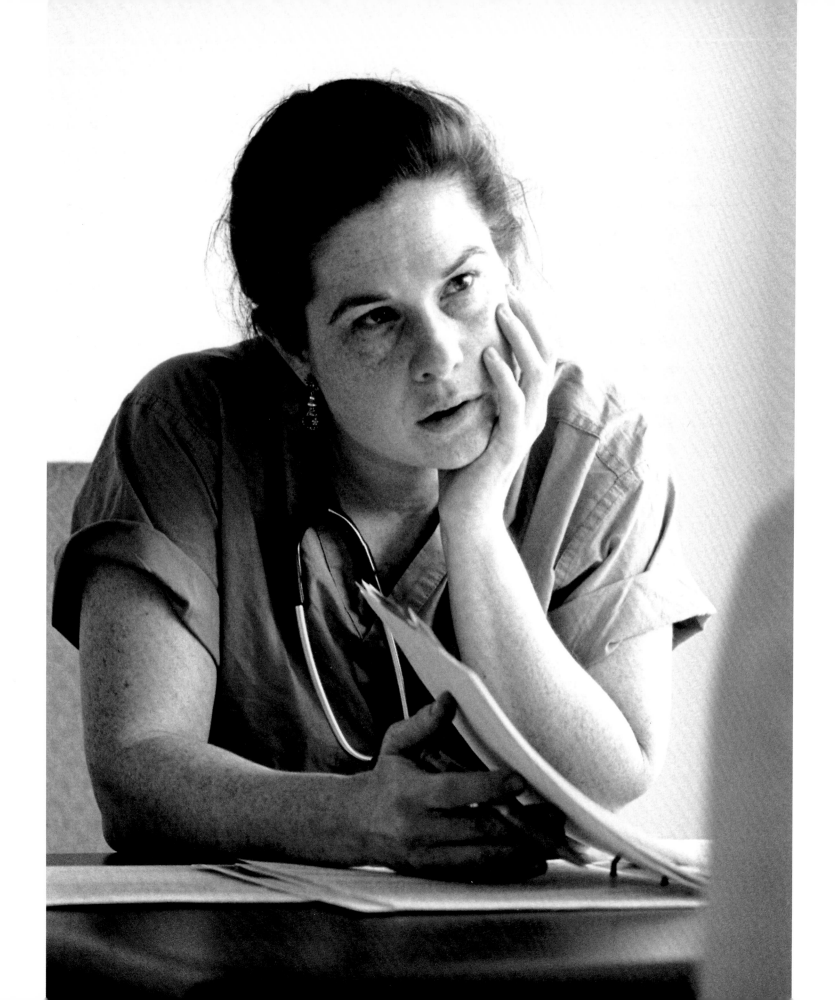

TABLE OF CONTENTS

*This book was created in part
with a generous contribution
to the photographers
from North Shore Long Island
Jewish Health System, New York*

PHOTOGRAPHERS' PREFACE

The role of women in medicine was unfamiliar to us until two years ago. At that time, while we were working on an unrelated assignment, Dr. Jennifer Mieres (Director of Nuclear Cardiology at North Shore University Hospital, Manhasset, New York) posed the question: "Why don't you do a book like this on women in medicine?" She had been looking through *Doctors' Work: The Legacy of Sir William Osler* [Ted's first book documenting the medical field]. With her simple question, Dr. Mieres set us on a mission. We began creating photographs worthy of being reproduced in the book you now hold in your hands, a book portraying and honoring the dedicated women in medicine.

What you have before you is a tribute to all women medical professionals: the doctors, the nurses and the technicians who spend their lives giving care, providing comfort and easing the pain of millions around the world.

You will not find every discipline represented in this book; it is impossible to show them all. However, we have attempted to include a representation of the women in medicine encountered by many of us from birth, throughout our lives and up to the moment we take our last breath.

During the challenge of producing the photographs, we were privileged to spend time with many inspiring and generous women. You will not find posed pictures in this book. All the photographs were taken during the "real time" workday of these women.

We sincerely thank all of you who openly welcomed us into your offices and operating rooms, sharing moments of your professional lives. We trust you will be pleased with the results.

TED GRANT & SANDY CARTER

FOREWORD

For centuries before there were medical schools to formally train and accredit women as physicians, women had been healers and caregivers, learning through trial and error when caring for sick family members. Over the years, and in different cultures and spheres of the world, women have had doors opened to them and doors closed in their faces, as the values of the period and social expectations dictated. In the pages of this book, you will see through photographs the images of women in all fields of medicine, illustrating the distance they have come and the progress they have made. These images reveal not only women physicians and surgeons, but also nurses, technologists, therapists, physicians' assistants, researchers and volunteers, each of whom is vital and integral to a successful and well-rounded health care system.

Many of us may believe that the history of women in medicine is a recent one, dating back perhaps a few hundred years. In actuality, the first known women physicians were in Egypt as early as 1300 B.C. It would take more than three thousand years, however, before the United States would see its first female physician, Elizabeth Blackwell, and about another 150 years before women would make up the majority of the workers in the health care system.

The first women of medicine in the United States date back to colonial times. They were what we would today consider midwives and came to be very highly respected, not only in delivering babies but also in treating injuries and illness; they even became known by the term "doctresses." At this time, both men and women acquired their skills by working with experienced medical practitioners in apprenticeships that usually lasted about seven years. It was not until more structured requirements for medical practice came into existence that the number of women medical practitioners declined. Prospective doctors were required to become licensed and pass exams in order to practice. Because medical programs were closed

to them, women were unable to take the required exams to become licensed. As more men earned medical licenses, women, as healers and practitioners, lost their credibility and were relegated to positions of midwives only.

Because women were excluded from the mainstream profession of medicine, they tended to gravitate toward its margins. An interesting movement began to occur in the United States in the 1830s and '40s of which women composed the backbone. The Popular Health Movement was a crusade for women's health and introduced "Ladies' Physiological Societies." These societies offered simple courses in anatomy and personal hygiene, emphasizing preventive care. The movement advocated frequent bathing, loose-fitting clothing for women, whole grain cereals, birth control and a variety of other issues to which women could relate. These classes were immensely popular. The movement's philosophy, a direct assault on the medical elitism of the time, was "every man his own doctor" – and it was made clear that this slogan meant every woman too. These "irregular physicians," as they were called by the male medical establishment, often used herbal remedies and espoused the natural healing of the human body. It is estimated that of the approximately 2,500 homeopathic physicians of the time, two-thirds of them were women.

The peak of the Popular Health Movement coincided with the beginnings of an organized feminist movement in the United States, and the two were very closely linked. The health movement was concerned with women's rights in general, and the women's movement was especially concerned with health and women's access to medical training.

Despite the increasing numbers of "irregular physicians" and the numerous sects which the movement spawned, there were still women unwilling to be relegated to the margins of the medical field. They insisted on pursuing equal opportunities and gaining access to the formal medical training that men were offered. One such woman was Elizabeth Blackwell, the first American female doctor. She was accepted in 1847 to New York's Geneva Medical College and received her M.D. in 1849. Interestingly, she was accepted to the school only because of a unanimous, albeit unexpected, vote by the student body. Blackwell's victory did not, however, bring about a wide-scale acceptance of women into formal medical schools. The few who were accepted faced continual harassment from male students and faculty alike, and they also found it next to impossible to gain clinical experience once they had graduated. Medical schools argued that women were too fragile to endure the fatigue and mental stress of the medical profession. One well-known obstetrical textbook went as far as to say that "She [a woman] has a head almost too small for intellect, but just big enough for love."

In the face of such prejudice, equal rights advocates and women physicians believed that the logical solution to such closed doors would be the creation of all-women's medical schools. The first unchartered medical college for women was the New England Female Medical College in 1848. The first chartered medical school for women, the Female Medical College of Pennsylvania, opened its doors in 1851. Institutions like these not only provided women with opportunities, but also allowed for the special interest in women's health and children's health issues that had motivated many women to enter the medical profession in the first place. Between 1850 and 1890, 19 women's medical colleges were founded; however, once

these women acquired their medical education, it was difficult for them to gain clinical experience.

The women's medical colleges ushered in several "firsts" in the history of women and medicine. Although the medical community did not recognize the graduates to be physicians and, therefore, did not offer them clinical experience in hospitals, it did allow them the opportunity to found their own companion hospitals. The New York Infirmary for Women and Children, the very first hospital to be staffed entirely by women, was founded by Elizabeth Blackwell in 1857.

Despite the success at the time of women's medical colleges and their companion hospitals in offering opportunities for women physicians, there was still a desire for a coeducational system where women received the same benefits of and recognition from medical schools that men attended. As one student noted, it was "not because they are colleges of men, but because this is still so largely a man's world, with men so often holding a position of Best."

As it turned out, money ($500,000, to be exact, from feminist fundraisers) was the catalyst for the doors of coeducation to open up. In 1893, Johns Hopkins Medical School became the first to enroll a coeducational class – becoming a leader in offering opportunities for women in medicine. Many other schools followed suit and, by the end of the 19th century, women constituted one-fourth to one-third of U.S. medical students. Impressively, the number of female physicians rose from 2,423 in 1880 to more than 7,000 by 1900. This period has been deemed the "Gilded Age" in women's medicine; however, it would not be long lived. As the century drew to a close, radical changes would bring to a halt the strides that women had made.

At the turn of the century, the United States was emerging as the industrial leader of the world. The wealth of America was growing by leaps and bounds, prompting the birth of philanthropic organizations which would greatly affect the social, political and cultural lives of the nation. One of the foremost concerns for families like the Rockefellers and Carnegies was medical reform. The goal was to have all medical schools conform to the Johns Hopkins model, which integrated lab work in basic science with expanded clinical training. It also introduced the pattern of four years of medical school following four years of college. The Carnegie Foundation hired a man, Abraham Flexner, with no real medical background to judge the quality of U.S. medical schools in relation to the Johns Hopkins model.

The Flexner Report, published in 1910, delivered a crushing blow to medical schools in general, but women's schools in particular. His report not only stated (falsely) that women's medical schools need not exist since "medical schools were open to women on practically the same terms as men," but also recommended premedical schools, longer courses of study, stiff clinical requirements and the affiliation of medical schools with hospitals and clinics. Flexner was put in charge of the foundation's monies and, therefore, only those schools approved in his report received funding. As a result, two of the three women's medical schools that had survived into the 20th century closed, along with six of America's eight medical schools for African-Americans. Furthermore, Flexner's recommended educational requirements were very costly; working-class women did not have the economic resources to fund their education. This one report, in effect, slammed shut the doors that had been opened in

the previous century to women, African-Americans and poor white men. The medical field had officially become a white, male, middle-class profession. The enormous strides that women made in the late part of the 19th century would not resurface until the 1970s, a result of both the civil rights and feminist movements in the United States.

The Rise of Nursing

In the face of such opposition and barriers, women who wanted to pursue a career in medicine were limited to nursing. If doctoring was considered the masculine medical profession, nursing was, and still is to some extent, considered the feminine profession. Society's opinion of a woman's role as mother and wife became the prevailing attitude, and many women, rather than face repeated rejection from medical school, turned to nursing in the early part of the 20th century, although it was less prestigious and well-paying.

The first nurses date back to ancient societies. Often times they were slaves who were assigned to be caretakers, but were not properly trained. As centuries passed not much changed; these caretakers functioned as untrained and unpaid servants able to do little for most patients. Even well into the early 19th century, hospital nurses were notorious for being drunks, prostitutes and thieves. A woman by the name of Florence Nightingale, however, would change the image and perception of nursing for years to come.

Considered the founder of modern nursing in both Europe and the United States, Nightingale abandoned the comforts of her privileged upbringing and instead chose to care for the sick and needy. She is perhaps best known for her efforts during the Crimean War to properly treat wounded soldiers and replace disreputable nurses with sober, disciplined, middle-aged women. The somewhat idealized image of the nurse as the "Lady with the Lamp" was immortalized by Henry Wadsworth Longfellow in his poem "Santa Filomena":

> *A lady with a lamp shall stand*
> *In the great history of the land,*
> *A noble type of good,*
> *Heroic womanhood.*

Perhaps even more important was Nightingale's role as reformer. Her *Notes on Hospitals* revolutionized the theory of hospital construction and management. During her time tending to soldiers in the Crimean War, she single-handedly conceived plans for reorganizing military hospitals and insisted on keeping medical statistics, thereby reducing the death rate in military hospitals. She also proposed establishing an army medical school, which transformed the training of military doctors, and campaigned to make civilian hospitals keep uniform statistics about their patients and drew up plans for a model on how it could be done.

Nightingale brought to reality the concept of the completely trained nurse: she organized the Nightingale School and Home for training nurses at St. Thomas' Hospital in London, which offered a year-long course of study. Louisa Schuyler would be the driving force behind the creation of a similar style of nursing school in the United States.

Nightingale's personal beliefs did influence nursing in some less than positive ways. She did not consider herself a feminist and was not interested in furthering the rights of women or their equality. It was her belief that nurses need to be completely subservient to doctors, never questioning their judgment and never taking any action without the direct order of a doctor. She saw it as a natural vocation for women, second only to motherhood, even going so far as to say that "nurses cannot be registered and examined any more than mothers."

Though doctors might have been wary at first of nurses as another feminine attempt to infiltrate medicine, they were soon won over by Nightingale's model of unflagging obedience. As the doctor diagnosed, prescribed and moved on to the next patient, he needed a patient, obedient helper to provide the patient care. Two distinct spheres emerged: curing and caring. Doctors were responsible for the former and nurses for the latter. The doctor embodied the masculine characteristics of intellect and reasoning, while the nurse embodied the feminine characteristics of tenderness and spirituality. These stereotypes would persist for decades, and even to this day prove hard to dispel. According to 2003 Bureau of Labor statistics, of the approximately two million registered nurses employed in the United States, only 9.8 percent are men.

Allied Health Care Professionals

As the medical profession evolved as a result of technological demands and the specialization of medicine, the need developed for other allied health care professionals. There also came to be more of an emphasis on the treatment of patient and family as opposed to simple diagnosis. The term "allied health care" identifies a cluster of health professions and covers as many as a hundred occupational titles, including: nursing aides; physicians' assistants; medical orderlies; medical secretaries; laboratory technicians; medical technologists; occupational, speech and physical therapists; medical record clerks; social workers; and hospital administrators – to name just a few. Each of these professionals plays a crucial and invaluable role in the delivery of quality care to patients in hospitals, outpatient facilities and the home. It is this team approach of the allied professionals that offers the most complete patient care and fosters compliance with a prescribed medical and physical regimen.

The allied health workforce, the largest and most diverse in the United States, greatly influences health care delivery by supporting, facilitating and complementing the roles of physicians and other health care specialists. Approximately 3.3 million people, the majority of whom are women, are employed as allied health professionals in the United States. The collaboration emphasizes the strengths of all health professionals and enhances patient quality of care.

The Ongoing Struggle

There were, however, a small number of women who were not content with being nurses and struggled defiantly to become doctors. In 1915, the Medical Women's National Association (MWNA or National, later renamed the American Medical Women's Association) formed to help in the struggle. Its founder, Dr. Bertha Van Hoosen,

noted the need for coordinated action by women in medicine and the positive role that National could play for women in the profession. The organization surveyed hospital internships open to women and documented the scarce and inadequate postgraduate training opportunities. This report increased the organization's effectiveness as a lobbying tool for better training for women.

With the entry of the United States in World War I, many women doctors volunteered to join in the military medical corps. Dr. Van Hoosen offered National's membership to the medical reserves, but was refused. Overseas work provided many opportunities for professional advancement; however, women were legally excluded from the Army Medical Reserve Corps, the source of military physician recruits. National formed a War Service Committee to lobby the War Department for military commissions for women physicians and to care for civilian war victims. This committee became the American Women's Hospitals Service (AWHS). While the War Department refused to commission women physicians, the Red Cross accepted the offer to send women's hospital units overseas. By 1920, AWHS staffed nine hospital units and 20 dispensaries. Additionally, when thousands of young men went off to fight in Europe, medical schools, even Ivy League ones, reluctantly accepted women, fearing the loss of tuition income. There was again hope for would-be women doctors, but once the war was over and young men returned home, the doors were again shut. The percentage of women admitted to American medical schools declined from 6 percent in 1923 to 4.5 percent in 1928, and there was an appalling lack of progress for women in medicine in the 1930s.

World War II temporarily helped those who had become doctors. In 1940, the American Medical Women's Association (AMWA) petitioned the American Medical Association (AMA) for support in changing the law excluding women from the military reserves. It wasn't until 1943, when the physician supply could not keep up with demand as the Army increased thirtyfold, that the AMA and the Army and Navy Surgeon General withdrew their objections. The first woman to be commissioned into the Army Medical Corps, Dr. Margaret D. Craighill, was given the rank of major. Yet again, when the war ended women were no longer welcome in medical schools or internships, and some were even removed from their posts. By 1955 a new low had been reached. Many schools that had welcomed women during the war no longer had a single female student.

In spite of the barriers and gender discrimination at this time, there were women who defied the odds and not only earned medical degrees, but also went on to make historic contributions to the field of medicine; among them: Florence Sabin, whose discoveries on the lymphatic system had a dramatic impact on medicine; Helen Taussig, who co-developed the heart operation that saved "blue babies"; and Marjorie Horning, whose research identified the transfer of drugs from a mother to her fetus, a fact previously unknown.

The 1960s introduced a new set of challenges for women in medicine. Due to a post-war baby boom, government-subsidized hospital growth and the aging of the population, there was a greater demand for physician services. With the construction of 22 new medical schools between 1961 and 1971, combined with the power of both the civil rights and women's movements of the 1960s, applications of women to medical school tripled,

while male applications only doubled. Women medical students increased from 5.8 percent of total enrollment in 1961 to 10.86 percent in 1971.

During the 1970s and a climate of a liberalized political agenda, the AMWA acknowledged the need to demonstrate its commitment to family life, sex education, and tax benefits for domestic and child care expenses for all working women, not just physicians. Student interests were seen as bringing women faculty and students together, with the issues of medical education, sexual harassment, available residencies, abortion and other women's health concerns, and child care reaching the forefront. The percentage of first-year female students tripled from 1969 to 1979. By the 1999-2000 academic year, the proportion of accepted women medical students (45.7 percent) slightly exceeded the proportion of accepted men (44.8 percent). Women made up the majority of new entrants at 36 U.S. medical schools, up from 21 schools in the preceding year.

Early in the 21st century, we can see that statistics reveal both how far women have come and the room there is for even greater progress. One prediction estimates that by 2010 women will make up 30 percent of practicing physicians. In academic medicine, the proportion of women faculty members increased slightly to 28 percent. The percentage of new faculty hires who are women averaged 37 percent in 2000 compared with 32 percent in 1997. As of 2001, however, only 12 percent of all full professorships were held by women. Women department chairs totaled 180, representing just 7.5 percent of all department chairs. There are at least 23 schools with no women department chairs. Clearly, there is still room for substantial growth so that a higher proportion of women

physicians develop their leadership potential and progress in academic medicine.

The Need for Mentors

In order for women to continue to increase their numbers in the health care field, at least in terms of leadership positions, it is important that they have mentors. The original Mentor, as described by Homer, was a "wise and trusted counselor," and indeed a mentor can provide the invaluable support and direction needed to help ensure the success of a young female physician. It has also been shown that women physicians with mentors publish more articles, have increased employment opportunities, feel more confident about their capabilities and are more satisfied with their careers overall than those without mentors.

Since women constitute a minority of physicians, it is not uncommon for them to experience loneliness and isolation that can undermine their self-confidence and sense of belonging. A female mentor not only may offer career sponsorship, but may also provide younger physicians with an example of how to successfully combine a career and family. It is, however, important that one has several mentors and that there is gender balance. Many women leaders in medicine have had excellent male mentors and, because there are still too few women in senior mentorship positions, supportive male mentors are vital.

Strides We Have Made

Despite the obstacles that women have had to overcome in all fields of medicine, the strides they have made have been tremendous. They have irreversibly changed the

monolithic landscape that was medicine for many decades and have emerged not only as physicians, nurses and surgeons but also as deans of medical schools, hospital CEOs, department chairs and principal investigators of large grant-funded studies. As a result of women's movement into these varied areas in medicine, all women have reaped the rewards. In 1991, the National Institutes of Health formed the Office of Research on Women's Health, which has helped generate basic and epidemiological research on breast cancer, coronary artery disease, hormone replacement therapy, osteoporosis, AIDS and gender-based differences in disease, to name just a few areas. Furthermore, as the number of women has increased in academia and research, we have seen them spearhead maternity leave policies (which also benefit men to be home with new families), domestic violence education and legislation, and a renewed focus on public health and the rights of children.

Conclusion

As one can see, the contributions of women to medicine have been many, varied and consistent, if not always acknowledged, throughout history. It is these determined and courageous women who refused, in the face of adversity, to be denied their passion and calling for healing and caring that paved the way for women in medicine today.

While many doors have been opened, there are still additional challenges unique to women. A woman can most certainly have a successful, rewarding career in medicine if she chooses; however, it is complicated by the fact that she is often the foundation of the family and faces the challenge of balancing work and home, family and career. As health care organizations recognize the value of women in health care, they have risen to the challenge and are facilitating a flexible work environment that will foster the continued contributions of women in medicine.

A personal note of appreciation is extended to the pioneering women who came before me. All of the women mentioned here, and hundreds who went unnamed, braved formidable barriers in their paths and, in so doing, helped pave an easier entry for those who followed. I, and so many others, have arrived here in a long procession of women physicians, nurses, researchers, technologists, physicians' assistants, psychiatrists, surgeons and volunteers which widens in rank by the years.

I wish to thank Lesley Wood and Teri Ann Gershenson, whose help was invaluable.

JENNIFER H. MIERES, MD, FACP, FACC
Director of Nuclear Cardiology
North Shore University Hospital
Manhasset, N.Y.

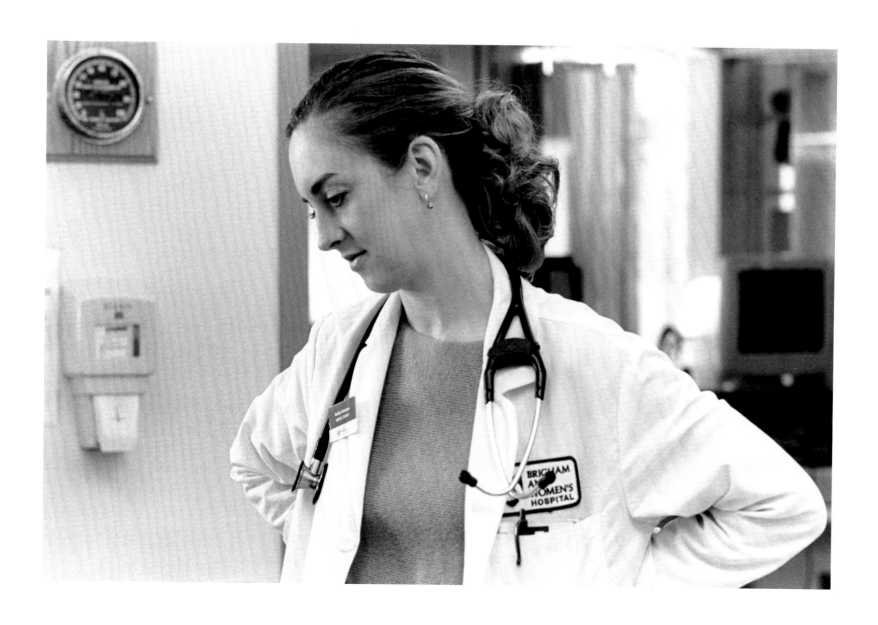

INTRODUCTION

All truth passes through three stages. First, it is ridiculed. Second, it is violently opposed. Third, it is accepted as being self-evident.

ARTHUR SCHOPENHAUER

Thinking about women in medicine alongside Ted Grant and Sandy Carter's striking photographs, which so eloquently capture the varied and complex realities of women's workaday lives, inspires reflection on the process of change. Today, it is self-evident that skillful women in a myriad of roles form the backbone of our health care system. Over 80 percent of health care workers are female, and on the homefront, care of the sick remains largely in female hands. Women, as physicians, nurses, medical researchers, hospital administrators, epidemiologists – the list goes on and on – have captured the popular imagination in books, movies and television shows, and their many achievements are widely covered in the media. In the medical world, as in others, doors that once were closed have swung open to reveal a new and expansive vision of women's lives.

With their trusted Leicas in hand, using only existing light and blending into the background, Ted Grant and Sandy Carter have given us access to this fascinating world of contemporary medicine. At first, some images seem intimidating – women working in settings punctuated by the maze of machines that are the stock in trade of critical care. But inevitably the focal point of the pictures becomes clear. They chronicle a fascinating web of human interactions. When the subjects' eyes reveal the essence of the scene, the effect is dramatic. Lively and engaged or intense with concern, the eyes consistently disclose the connection with others and concern for their well-being that is the foundation of medical care.

A feeling is palpable in the photos: the female subjects love their work. Helping people cope with life's many problems, physical and psychological, from life-threatening trauma to the infirmities that come with old age, is more than a job. It is a major component of the subjects' being, one that is deeply gratifying. They seem at home in their setting, so much so that it is easy to forget their mere presence represents centuries of effort to prove that ability not biology should determine opportunity, not only in health care but in every other facet of our lives.

Social change is incremental; a series of small steps in

Observing surgery at St. Luke's Hospital, New York City, c. 1890.

many different areas that cumulatively and over time change the way we see the world. If women can now aspire to leadership positions in the medical world it is due to the achievements of the thousands of women who preceded them. Each, in her own way, helped to create the climate of equality women now take for granted by challenging the status quo and chipping away at the stereotypes governing attitudes toward women. Often they served as lightning rods for opposition to women's equality, enduring ridicule and harassment. Together their stories provide a continuum of female achievement that enlightens and ultimately inspires contemporary women. It is a heritage medical women can be proud to call their own.

Hildegard of Bingen, a 12th century German nun, is

one of the great figures in the history of medicine and one of the first to leave behind extensive documentation of her life. Her body of work includes two significant scientific works, *Causae et Curae* or *Liber Compositae Medicinae* (Book of Advanced or Applied Medicine), an early medical textbook, and *Physica*, or *Liber Simplicis Medicinae* (Book of Simple Medicine), an encyclopedia listing the medicinal value and proper application of over 200 plants. Hildegard was the first woman to write about plants in relation to their properties and *Physica,* which was the first book of natural history written in German, became a standard reference for many future generations of botanists.

In addition to being a scholar, Hildegard was a woman of power and influence whose collected letters reveal an impressive correspondence with the significant religious and political figures of her time, including Henry II of England and Eleanor of Aquitaine. Her work ranged widely through many disciplines, from medicine to poetry and theology, and has been compared to that of the great philosophers. And yet, toward the end of her life, when she was telling her biographer about her experiences, Hildegard felt compelled to remind him that her abilities were initially questioned because she was a woman. Revisiting her youth, she remembered that many were shocked by her sense of self, which was perceived to be out of place for a female. "What is this?" they asked. "So many mysteries are revealed to this foolish and unlearned woman when there are so many strong and wise men? It will come to nothing for sure!"

It would be reassuring to know that Hildegard's remarkable career paved the way for a steady stream of women who followed, but clearly this was not the case. Discrimination became a common theme in the long and frequently dramatic saga of women in medicine and, until relatively recently, few women broke through to the upper echelons of the profession. Health care may be women's work, but in man's world, women's place was usually in the background.

"The practice of medicine is an art, not a trade; a calling, not a business, a calling in which your heart will be exercised equally with your head," said Sir William Osler, the 19th century physician who changed the face of modern medicine by teaching that medical skills are learned by the bedside and not in the classroom. As many of the photographs in this book reveal, the warm reality of other people is the stock in trade of health care workers and their professional interactions bear a striking resemblance to family intimacy, reflecting medicine's origins as a facet of female domesticity.

The personality traits associated with caregiving, such as concern, compassion and good listening skills, have traditionally been designated as "feminine" and, as Osler suggested, medicine is a relational art. Today, women tend to cluster in primary care specialties like family medicine to some extent because they allow for more involvement with their patients. Studies show that female physicians spend more time listening to their patients, take down more comprehensive information about their lives and pay closer attention to their needs. Not surprisingly, many patients prefer this style. As a result, they often believe they receive better care from women doctors.

Conventional wisdom suggests that women have better relational skills than men, but they also have a long tradition of being skilled in the more technical aspects of health care. For instance, women's role as health care providers in the family provided "hands on" training in

childbirth and, as women cared for women, they developed extensive knowledge about reproductive matters. In ancient Egypt the medical schools at Heliopolis and Sais included female faculty members and, in fourth century Greece, a legendary beauty named Philista was a popular professor of medicine, even though she had to deliver her lectures from behind a curtain to protect the audience from her dazzling good looks. Several ancient writers tell the tale of Agnodice, a popular Greek gynecologist, who disguised herself as a man in order to work as a physician. Trotula, an Italian of the medieval period, was another highly esteemed physician and obstetrician, who authored a book on the conditions of women. In Italy, where some women were allowed to attend university, Dorothea Bocchi was appointed professor of medicine in Bologna in 1390, and records show that in the 15th century Costanza Calenda of Naples received her doctorate in medicine.

But in the past, women physicians were the exception rather than the rule and most women provided health care as friends, neighbors and members of families in response to community needs. Caregiving was a socially acceptable component of women's homemaking role. As St. Augustine wrote in the fourth century, "Educated women should take care of the sick and wounded at home, attend women in confinement, bleed or cauterize all who request it and gather herbs for medicines."

Although women were identified as natural caregivers and accepted responsibility for health care in the home, whenever they sought professional recognition for their skills barriers emerged. Gradually, medicine became associated with academic learning and licensure, which was reserved for men. It was a challenge for any woman with an interest in the healing arts to maneuver her way through this minefield.

Consider the case of Jacoba Felicie, a woman practitioner, who in 1322 was charged in Paris with practicing medicine without a license. Six of the seven witnesses at her trial testified that she had succeeded when other physicians had failed. In her own defense, Jacoba raised the issue of women's greater comfort level with a physician of the same sex. "Some women may be embarrassed by having to go to a man for a cure. I have proved my ability to cure and heal the sick. Surely it is better that I am allowed to make visits than patients die through the failures of licensed doctors."

Unfortunately, the court didn't agree and Felicie was found guilty, along with four other women healers. In those days, men, with the support of the Church, ensured that they would dominate medicine by excluding women from higher learning so they had no way to obtain the licenses necessary to practice medicine. Moreover, during this time, the guilds of physicians and surgeons were forming and women were excluded from membership.

The position of women healers became even more precarious during the transition from the Middle Ages to the Renaissance, which was a time of intense turmoil in Europe. Natural disasters such as the bubonic plague, seemingly endless warfare, and movements for social change and religious reformation created intense instability. The witch hunts were one result of this climate of unrest.

Women healers, who violated the prohibition against unlicensed practitioners, were frequent targets of the witch hunters. In the Church's view, academic and clerical learning were the only acceptable sources of knowledge,

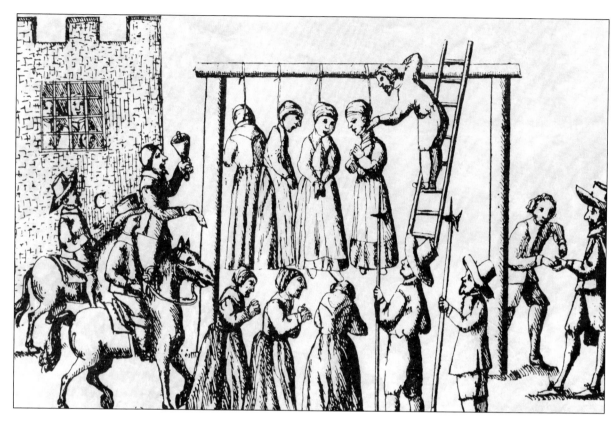

An execution of witches in England.

so self-taught women who learned by experience and passed-on wisdom based on empirical knowledge were a menace. Thus the Church declared in the 14th century, "If a woman dare to cure without having studied, she is a witch and must die."

The more skilled a woman healer was, the more dangerous she seemed. By curing the sick and easing pain, women healers challenged the power of the Church, which taught that sickness was God's punishment for being wicked and that suffering on earth brought rewards in the hereafter. Midwives, who eased the pain of childbirth, were particularly threatening as the Church taught that labor pains were "Eve's curse," which all women were doomed to suffer as penance for their predecessor's transgression in the Garden of Eden.

While historians are unsure of how many deaths resulted from the witch hunts, it is certain that thousands and thousands of innocent women were burned at the stake, taking their substantial medical knowledge to their graves. The witch hunts stalled the advancement of midwifery but they didn't halt it completely. Throughout the period, medical education for midwives continued to evolve and in some jurisdictions, such as Germany and France, standards were becoming relatively high. Outstanding midwives in France included the royal midwife, Louyse Bourgeois, a 16th century practitioner who wrote a three-volume manual on midwifery. In the 18th century, Angelique Marguerite le Boursier du Coudray traveled throughout the country under the auspices of Louis XVI teaching midwifery to village women. But despite the example of

outstanding practitioners and official acknowledgment of their skills, conflict regarding the licensure of midwives and their entry into universities continued into the early 20th century.

In North America medicine took a different path. In colonial America, as in other jurisdictions, health care, particularly childbirth, was the provenance of women who often drew on the natives' knowledge of medicinal herbs for their healing potions. But by 1800 doctors began to displace midwives at a far more rapid rate than they had done in Europe, influenced to some extent by America's Protestant culture, which was more accepting of science than the Catholic Church. However, despite their scientific veneer, most of the male doctors of the time knew very little about medicine. Worse still, many were hazardous to their patients' health. Such was the sorry state of their knowledge that they were likely to engage in debilitating practices, including bloodletting and purges, or prescribe "tonics" containing poisonous substances, such as arsenic and mercury. These treatments often produced disastrous results. Eventually, the public lost faith in the medical professionals and demanded reform.

In the early 19th century, the Popular Health Movement challenged the medical establishment. Their efforts were so successful that by mid-century there was a group of middle-class women who aspired to become physicians. One of their concerns was the potential for sexual abuse implicit in the male doctor–female patient relationship. Standards of propriety prevented many male doctors from properly examining their female patients, and many women would not allow themselves to be examined by a male doctor, preferring to live with illness rather than submit to a medical examination. As one patient told

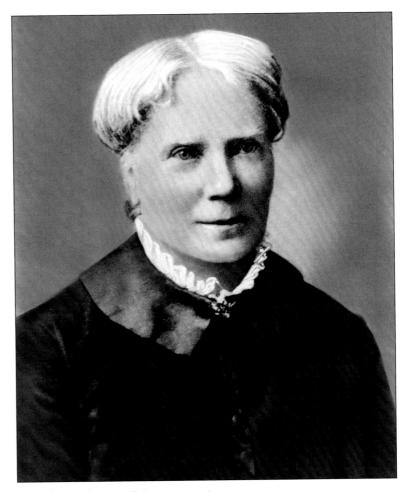

Elizabeth Blackwell (1821–1910).

Elizabeth Blackwell, who became America's first woman physician, "If I could have been treated by a lady doctor my worst suffering would have been spared me."

Thus, when Elizabeth Blackwell reflected on her career choice, she concluded, "The idea of winning a doctor's degree gradually assumed the aspect of a great moral struggle, and the moral fight possessed attraction for me."

While women fought to be allowed to study medicine, nurses struggled to gain recognition for their work. As

Antonia Fraser points out in her book *The Weaker Vessel*, it wasn't until the English Civil War, which began in 1642, that nursing began to gain official appreciation in England. During the various campaigns, fundamental supplies and services were lacking. Because they didn't have movable hospitals, injured soldiers were left where they fell and since surgeons were scarce, the wounded weren't likely to be treated. Fortunately, local women rose to the occasion. Housewives, who viewed nursing as part of their domestic duty, cared for the sick and wounded, often at their own expense and irrespective of the side they were fighting on. When she was criticized by a Roundhead captain for helping a Royalist prisoner, Lucy Hutchinson replied that she was doing "what she thought was her duty in humanity to them as fellow creatures, not as enemies."

Although nursing had not yet become an identifiable profession, its value was becoming increasingly obvious to some. The English General Venables, who led an ill-fated expedition to the West Indies, noted that if more women had gone, fewer men would have "perished as they did for want of care and attendance." Some French soldiers of the time demonstrated similar awareness. The men who set sail for Quebec with Paul de Maisonneuve in 1641 requested that a female nurse accompany them on the expedition in case they fell ill. Thanks to an endowment from a wealthy French woman who wanted to fund a hospital in the colony, Jeanne Mance was able to accept the position.

This extraordinary woman was born in 1606 near Langres in France's Champagne region. After witnessing the devastating effect that war and epidemic had on her community, she decided to dedicate herself to nursing the sick. Inspired by the three Ursuline sisters who founded a school for native girls in Quebec, Mance arrived in the colony in 1634 and spent her first winter in Quebec caring for the settlers there. The following spring she sailed up the St. Lawrence with de Maisonneuve to what is now the city of Montreal.

She established her first hospital in a tent, where she treated the soldiers, who were often wounded in their frequent skirmishes with the Iroquois. Tenaciously, she planted medicinal herbs, which she used for treating the sick. Less than four years after her arrival she was building a permanent hospital, which became the colony's first Hôtel-Dieu, a valuable resource as relations with the Iroquois did not improve. Sister Marie Morin, who joined the settlement several years later, wrote that even then the Iroquois attacks were "so sudden and frequent that there is no safety for us. They kill our people and burn down our houses … our hospital is far from being secure and we have had to place a strong garrison to protect it."

Although the Hôtel-Dieu has moved to another site and been rebuilt many times, the hospital Mance founded is still in operation in Montreal. She is a legendary figure in the city, where she is recognized as one of its founders. A major thoroughfare and a public park are named after her, a tribute not only to her but also to nursing and the role it played in the founding of Canada.

While it is impossible to understand the range of feelings that motivated Mance to set sail for Montreal, it is reasonable to assume that the desire for self-fulfillment played a role in her decision. The wilderness could be a liberating experience for women because it allowed them to escape from the confining sex roles that characterized society, creating opportunities for self-actualization that were normally denied to females. The battlefield served a

similar function. By giving women the opportunity to leave their homes to care for wounded soldiers, war provided visibility in the public sphere normally reserved for men. Combat nurses did more than save lives and ease suffering. They blazed a trail for women as professionals.

Florence Nightingale, whose heroic efforts during the Crimean War earned her a place in history, was the first woman to carve out that path, and her work profoundly influenced the development of nursing around the world. Born in 1820, Nightingale was educated at home and her family expected her to make a good marriage, like all proper young ladies of the era. But by the time she was 17, she had made a decision to live a different kind of life, heeding the call of a voice that told her she should devote herself to doing God's work. Her interest in nursing developed gradually and without the support of her parents, who felt it was an entirely unsuitable occupation for a young lady. In fact, they were so opposed to her career choice they made her promise to keep her training a secret.

Nightingale accepted her first nursing post in 1853 when she became Superintendent of an "Establishment for Gentlewomen during Illness." The following year the Secretary of War recruited her and 38 other nurses for service in the Crimea, where the conditions were appalling. Soldiers were dying in droves and newspapers were blaming the British command. Not only were the hospitals poorly equipped, wounded soldiers were being left unattended in the fields because there was no one to care for them, a situation worsened by epidemics of cholera.

Nightingale's administrative skills far exceeded her practical nursing ability, but these were the qualities necessary to succeed in the Crimea. A woman of steely resolve, she went toe to toe with the army medical corps who had little interest in helping a woman and an outsider, and she soon had supplies reaching the men for whom they were intended. Her nurses went to work cleaning the hospitals and caring for the sick and wounded. But it was a losing battle. Although the nurses made necessary improvements, the mortality rate remained high due to the unsanitary conditions at the hospital.

Even so, Nightingale's work during the war made her a household name and a national heroine and, ultimately, raised the esteem in which nursing was held. Requests for some sort of public testimonial to honor her contributions resulted in the Nightingale Fund. Although at the time there were many differences of opinion about the role of nursing and the kind of recruits it should attract, this national scheme raised funds for training nurses with a view toward creating a new profession for women.

After her return from the Crimea, Nightingale became even more committed to the cause of sanitary reform, and her efforts soon spread into broader areas of health policy. She came to understand that good nutrition, adequate housing, sound infant care and clean air and water were essential to public health, and she was an advocate for these improvements. Thanks to her experience in the Crimea, she recognized there was little use in providing good medical care if hospitals operated in conditions that were unhygienic, noting that "the very first requirement in a Hospital (is) that it should do the sick no harm."

Although the image of Nightingale is indelibly linked with that of the Lady with the Lamp, an angel of mercy caring for sick and wounded soldiers, her most significant career achievements came after her return from the Crimea, when she was suffering from a debilitating illness, likely contracted during the war. As Benjamin Jowett,

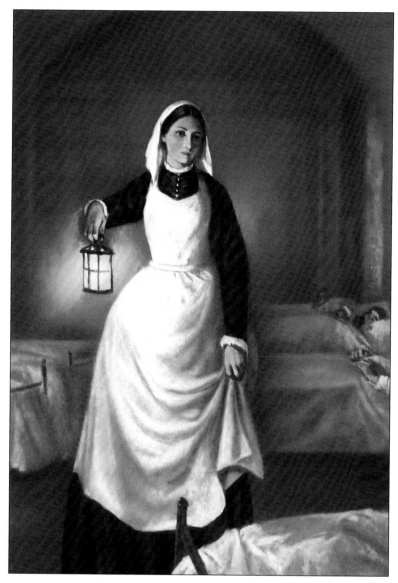

Lady with the lamp – Florence Nightingale (1820–1910).

diligence; how many natives of India … have been preserved from famine … by the energy of a sick lady who can scarcely rise from her bed."

In fact, Nightingale's real brilliance was not in providing "hands on" care to the sick but in mathematics and systems analysis, which had a profound impact on health care over the long term. She was a brilliant statistician, whose most lasting contributions to the health care system were improvements that came about by innovations such as record keeping. She was also an early promoter of monitoring treatments with a view toward establishing their effectiveness, which today we identify as "evidence based health care," having developed a statistical form that enabled hospitals to collect data on a consistent basis. Not only did her data drive improvements in medical and surgical practices, mathematicians were so impressed by her work in medical statistics that in 1858 she became the first woman elected to membership in the Statistical Society of England.

While Nightingale's reforms had a profound impact on health care in England, her influence extended around the world. In 1859 she published *Notes on Nursing: What It Is, and What It Is Not*, the first textbook on the profession, which is still in print today. She was so well-known and highly regarded that when Civil War broke out in the United States, the government asked her to consult on army health. She was also an outstanding role model and she inspired other women, some of whom volunteered to serve as wartime nurses. "I knew what one woman had done another could," said Kate Cumming of Mobile, Alabama, who overcame her family's opposition and volunteered to work as a nurse during the American Civil War.

When the war erupted in 1861, neither side was fully

master of Oxford's Balliol College, wrote to her in 1879, "There was a great deal of romantic feeling about you … when you came home from the Crimea. And now you work on in silence and nobody knows how many lives are saved by your nurses in hospitals … how many thousands of soldiers … are now alive owing to your forethought and

prepared for the devastating effect it would have, but the country's women as well as its men answered the call. For the first time, women went to work for the government as clerks and copyists, becoming known as "government girls." Others took over the backbreaking responsibilities of running farms and many volunteered to serve as nurses, even though they had little or no practical experience and formal training was nonexistent.

During the Civil War, more than 5,000 women served as nurses. Much of what they did was basically an extension of their traditional domestic roles. Not only did they care for sick and wounded soldiers, they wrote letters home for the men and notified the families of those who didn't survive. Cumming worked in a number of hospitals throughout the south and this description of her daily routine, written in March 1863, provides a snapshot of the life of a Civil War nurse.

"Mrs. Williamson and I live like Sisters of Charity; we get up in the morning about 4 o'clock and breakfast by candle-light, which meal consists of real coffee without milk, but sugar; hash and bread; we eat in our room. Unless we get up early, we find it impossible to get through our duties. After the duties of the day are over, we then write letters for the men, telling their relations they are here, or informing them of their decease; other times mending some little articles for them. Mrs. Williamson is up many a night till 12 o'clock, working for her 'dear boys,' as she calls them."

Even though Cumming, like many other nurses, was often working at jobs she might have done at home, her family opposed her decision to become a nurse on the basis that it was no job for a "refined lady." As Barbara Haber writes in her book *From Hardtack to Home Fries:*

An Uncommon History of American Cooks and Meals, the pressure for women to remain in the domestic sphere was very strong, especially "in the Confederacy, where well-born women were dogged by their culture to retain their traditional identity as genteel ladies ... It took a rare breed of Southern women to serve in military hospitals, yet where they did, the mortality rate dropped from 10 percent to 5 percent."

The cumulative effect of women's contributions to the war effort was extraordinary. On the Union side, they resulted in permanent improvements to government infrastructure. In April 1861, some prominent Union women met in New York City to discuss what they could do to help. The group included Louisa Schuyler, who went on to found the country's first training school for nurses at Bellevue Hospital in 1873, and Elizabeth Blackwell, who in 1849 became the first American woman to obtain a medical degree when she graduated at the top of her class from Geneva Medical College. At the time, Dr. Blackwell and other pioneering female physicians, including her sister, Emily Blackwell, Ann Preston and Marie Zakrzewska, were fighting battles on numerous fronts to increase women's access to medical training and licensure. Yet Elizabeth Blackwell vividly recalled the announcement of war and remembered its devastating effect. "In the full tide of our medical activity in New York ... the great catastrophe of civil war overwhelmed the country and dominated every other interest."

With the support of other prominent women, they formed the Women's Central Association of Relief for the Sick and Wounded of the Army and immediately began organizing to supply trained nurses to the front lines. This organization became an impetus for the establishment of

Clara Barton (1821–1912) and Red Cross Workers in Cuba, 1898.

the United States Sanitary Commission, which oversaw the welfare of the troops. Local chapters of the Commission, run by women volunteers, raised substantial amounts of money, collected necessary provisions for the troops and arranged to have them shipped to the field. Commission doctors worked as inspectors, helping to ensure that standards regarding "diet, clothing, cooks ... in fact everything connected with the prevention of disease" were met.

In June of 1861 the Commission took a major step forward when it agreed to accept the services of Dorothea Dix, who volunteered to serve in the war effort. This noted social reformer, whose work in prison reform and mental health institutions had dramatically improved conditions for inmates, was appointed as the Commission's Superintendent of Nurses. Although not a nurse herself, Dix was a great admirer of Florence Nightingale, whom she saw as a role model.

A highly focused manager, whose commitment to getting the job done earned her the nickname "Dragon," Dix worked with the Women's Central Association of Relief in

their efforts to supply trained nurses to the front. Given the social attitudes of the time, which suggested that nursing was not an occupation for respectable women, her first challenge was to convince military officials that she could recruit women who could do the job. In an effort to divert criticism, which she anticipated, she advertised for very "plain-looking women" who dressed austerely. She also established a formal training service for her recruits. A superb administrator who left no stone unturned in her tireless work on behalf of the war effort, Dix created and staffed infirmaries, supervised sewing societies and stockpiled medical supplies while overseeing the welfare of her nurses and the soldiers they cared for. Thanks to her efforts and those of the women who pushed for the formation of the Sanitary Commission, the mortality rate for Union soldiers was far lower than their Confederate counterparts.

Clara Barton, another legendary figure in the history of women in medicine, went on to found the American Red Cross following her experiences in the Civil War. Coming from a patriotic family – her father had fought in the Revolutionary War – she was devastated by the number of wounded soldiers she saw in the streets of Washington. Originally a teacher, who established New Jersey's first free school, she soon recognized that the Union army was not equipped to supply its troops and take care of their medical needs, so she volunteered to deliver resources directly to the front herself. It took a year of political lobbying before the government accepted her offer. In the meantime, working as a private citizen, she advertised for medical supplies and food, recruited her friends into service and used her home to stockpile provisions for the troops.

A woman of vision and determination, who had more than her fair share of organizational ability, Barton had many outstanding qualities. But it is her bravery and compassion as a nurse that earned her the title by which she is known today. After traveling by mule-drawn wagon through the night, she arrived at Antietam Battlefield, where she delivered a load of medical supplies to the desperate surgeons. The gunfire was heavy, but she was undeterred, moving through the body-strewn field, bringing water and comfort to the wounded men and helping the surgeons with their work. Apparently fearless and totally committed to her task, she astonished observers such as Dr. James Dunn, an army surgeon. As he later said of her efforts on behalf of the troops, "In my feeble estimation, General McClellan, with all his laurels, sinks into insignificance beside the true heroine of the age, the angel of the battlefield."

After the war ended, Barton continued her humanitarian work, shifting her focus to search for missing soldiers. She began with a letter-writing campaign and then established an agency dedicated to the cause. Not surprisingly, by 1869, Barton was completely exhausted and she traveled to Europe for a much-needed rest. However, when war broke out between France and Prussia the following year, her humanitarian spirit took over. The Red Cross, a relatively new organization founded in 1864, organized a relief effort, which she joined. Her work, which involved distributing supplies on both sides of the conflict, earned her the Iron Cross of Merit from the Emperor of Germany.

Barton was so impressed with the work of the Red Cross that she turned her formidable political skills to lobbying to ensure that the U.S. signed the Geneva Agreement. This paved the way for the establishment of an American branch of the organization, which she founded in 1881. As head of the American Red Cross, she

organized a team of nurses to deliver aid during the Spanish-American War, which began in April 1898, and found herself fighting another gender battle in order to recruit nurses for the conflict. Despite the outstanding example provided by women such as herself during the Civil War, the U.S. Surgeon General moved to stop her recruiting on the basis that only men could work with battlefield casualties. But he had underestimated the temper of the times and the esteem in which Barton was held. A public outcry of support for her efforts forced him to reverse his position. Shortly after she passed away in 1912, the *Detroit Free Press* summarized the public's feelings about Barton in an obituary: "She was perhaps the most perfect incarnation of mercy the modern world has known."

Although women doctors were a rare species during the Civil War, a few distinguished themselves during the conflict. Mary Edwards Walker became the only woman ever to earn the Congressional Medal of Honor, the country's highest military honor. An 1855 graduate of the Syracuse Medical College and the only woman in her class, Dr. Walker tried to join the Union Army when war broke out but was denied a commission as a medical officer on the basis of her sex. However, the situation soon became so desperate that the army allowed her to serve as an acting assistant surgeon and later as a field surgeon. "She lived a life of determined unconventionality," wrote Edwin M. Stanton, Secretary of War. "Being a bloomerite from her younger years, she preferred to dress in pants. Later on in life, still practicing medicine, she could be seen wearing men's top hats and top coats as well as pants."

Although Dr. Walker's attire may have been liberating on the battlefield, it identified her as a male to enemy soldiers.

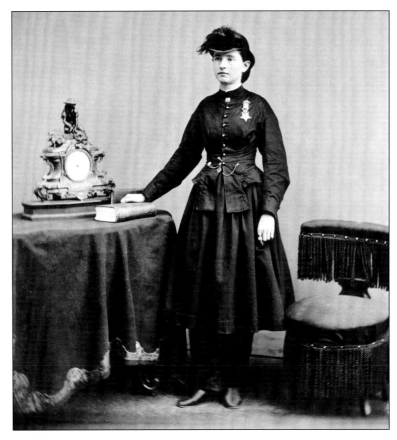

Mary Edwards Walker (1832–1919), c. 1850.

She was taken prisoner of war in 1864 and spent four months in a Richmond prison. After her release she is believed to have worked as a spy. In 1865 she was awarded the Congressional Medal of Honor for "meritorious services" by President Andrew Johnson.

Subsequently, Dr. Walker became active in the suffrage movement and in 1917, along with 910 other recipients, was stripped of her medal when Congress revised the standards to include only "actual combat with the enemy." One can only admire her courage when she firmly refused to give it back. Finally, in 1977, her beloved medal was reinstated posthumously by an Army board, which cited

her "distinguished gallantry, self-sacrifice, patriotism, dedication and unflinching loyalty to her country, despite the apparent discrimination because of her sex."

As a woman who sought fulfillment in a career, Dr. Walker, like her female colleagues, was accustomed to discrimination. In the mid-19th century, when she graduated from medical school, women who wanted to become doctors were denied access to the profession as a matter of routine. The prevailing belief was that no real woman would want to be involved with the gory work associated with medicine. Women who sought to obtain medical training despite these attitudes were doing more than aspiring to professional status. They were challenging the social role of women.

Not surprisingly, these trailblazers encountered serious opposition. In 1850, after finally gaining admission to Harvard Medical School, Harriot Hunt was forced to withdraw by her fellow students. The men objected "to having the company of any female forced upon us, who is disposed to unsex herself and to sacrifice her modesty by appearing with men in the medical lecture room (where) no woman of any true delicacy should be found."

Elizabeth Blackwell applied to 29 medical schools before being accepted by Geneva Medical College, and although she graduated at the top of her class, no American hospital would allow her to practice. Dr. Blackwell traveled to London, where she received the support of her old friend Florence Nightingale, then went on to Paris where she took training as a midwife. When she returned to the United States she set up private practice in her home.

The situation was even more challenging for women in Canada, who had to attend medical school in the United States as no Canadian school would have them. It is an interesting historical footnote that the first woman to practice medicine in Canada did so as a man. In 1857 Dr. James Miranda Stuart Barry, who was Canada's chief military doctor, was appointed Inspector General of Hospitals for both Upper and Lower Canada, a tribute to his superior medical skills. It wasn't until he died that his secret was revealed – Dr. Barry was actually a woman. Although her identity as a female is not certain, Dr. Barry had been posing as James Barry since 1809 when she enrolled at the University of Edinburgh in Scotland.

The first doctor to actually practice as a woman in Canada was Emily Stowe. After being refused admission to the University of Toronto because she was a woman, she became a teacher, graduating from teacher's college with a First Class Certificate. This was considered such an exceptional achievement that she was appointed principal of a school, the first woman in Canada to be so honored.

Two years later, in 1853, she interrupted her teaching career to marry and have children. When her husband contracted tuberculosis, Stowe, who was now the family's breadwinner, decided to become a doctor and, when no medical school in Canada would accept her, she enrolled in the recently established New York Medical College for Women. She graduated as a doctor, returned to her family and set up practice in Toronto. Then two years later, in 1869, the government passed an act requiring that doctors be licensed and established The College of Physicians and Surgeons of Ontario as the licensing board with jurisdiction for Toronto.

Dr. Stowe applied for a license to practice and was refused. The College rules stipulated that graduates from American medical schools must attend specific lectures at a

medical school in Ontario before they could be registered to practice in the province. The problem was that no medical school in the province would accept women. Dr. Stowe was so enraged that she continued to practice illegally, while persistently applying to medical schools. Finally, the Toronto School of Medicine agreed to accept her and another young woman, Jennie Trout, who had graduated from the Woman's Medical College of Pennsylvania in 1875.

The two women were accepted only after they agreed that they would not complain even if unfortunate incidents occurred while they attended class. Not surprisingly, the school environment was hostile and they were constantly harassed. Despite the unpleasantness, Emily Stowe and Jennie Trout succeeded in gaining the credits they needed to be licensed as physicians. Fueled by their experience, both went on to play instrumental roles in establishing medical schools where women could learn in peace. Stowe helped to found the Women's Medical College in Toronto and Trout played a similar role in getting the Kingston Women's Medical College off the ground. Both these institutions closed their doors when university-affiliated medical schools began to admit women, shortly after the turn of the century.

Augusta Stowe-Gullen, Emily's daughter, also made medical history when, in 1883, she became the first woman to receive a degree from a Canadian medical school. But there wasn't much value in having a medical degree if there was no place where a woman could practice. Hospitals wouldn't hire women doctors, so in 1898 the group that founded the Women's Medical College opened a clinic. Not only could women physicians practice in a hospital-like setting, their female patients could be treated in a

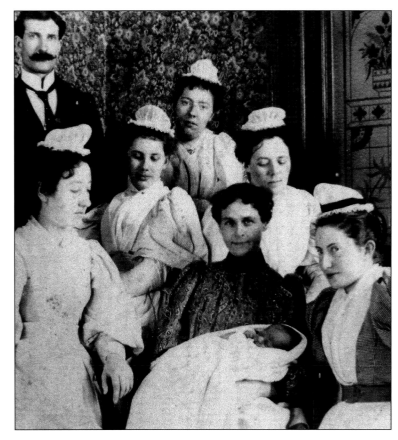

Dr. Augusta Stowe Gullen (1851–1943) holding first baby born at Toronto Western Hospital, c. 1896.

professional environment rather than in the doctor's home. This clinic evolved into Women's College Hospital, which became a world-renowned institution specializing in women's health.

Despite the obstacles, a fair number of women braved the course and acquired medical degrees during the late 19th century. The 1870 Federal Census records listed 527 women doctors in the United States and by 1900 that number had increased to 7,387. Some of these were African Americans. By 1890, there were 115 female African-American physicians in the United States who faced the added challenge of addressing the needs of the under-

serviced African-American population. Often they worked as "sanitary visitors." These traveling physicians visited families in their homes to instruct them in matters such as hygiene and infant care.

African-American women also had a long tradition as community healers. They were midwives and herbalists and were frequently described as "Doctors" in plantation inventories. Harriet Tubman, who became famous for leading former slaves to freedom on the Underground Railroad, gained practical nursing experience when the fugitives she was helping became sick. During the Civil War, she worked as a nurse for the Union side and may even have served as a spy. But it wasn't until 1879 that Mary Eliza Mahoney became America's first trained African-American nurse when she graduated from the New England Hospital for Women and Children.

In the later part of the 19th century, institutions such as Howard University were founded to provide higher education for African-American people. Initially, the medical school at Howard was open to members of both sexes, but the institution soon moved to limit enrollment to men. The first African-American woman to receive a medical degree was Dr. Rebecca Lee, who graduated from the New England Female Medical College in 1864 and, in 1883, as Rebecca Lee Crumpler, authored a medical book focusing on infant care. Rebecca J. Cole followed her example, graduating from the Woman's Medical College of Pennsylvania in 1867.

Although the licensure of physicians has had a long tradition, regulating nurses was a controversial idea when it was first proposed in the late 19th century. Many people felt, like Florence Nightingale, that "every woman is a nurse" and were appalled by the thought of regulating skills they believed were inherently feminine. Others, including hospital administrators, who relied on the low wages traditionally paid to nurses to keep their institutions running, objected to regulation for economic reasons. They understood that if nurses were recognized as professionals, the cost of labor would rise in accordance with their higher status.

One leader in the campaign for registration was Ethel Bedford Fenwick, the matron of St. Bartholomew's Hospital in London, England, who justified her opinion in the July 1888 issue of *The Nursing Record*. "It seems to me that few Nurses realize the fact that a momentous crisis in the history of their calling has somewhat suddenly arrived," she wrote. "The question ... is simply this – Is Nursing to remain a mere vocation, which can be adopted by anyone, learnt without careful training, and practiced without experience being absolutely requisite: or is it to be transformed into the foremost and first female profession, recognized, constituted and organized by the law of England? Are Nurses to remain, as they are now, individuals who are classed in the public mind with domestic servants or are they to become members of a great and skilled profession, with clearly defined training acquirements and duties?"

After a long and often heated debate, England chose to recognize nurses as professionals and passed the Nurses Registration Act in 1919. Despite its leadership, England wasn't the first country to pass legislation to regulate the profession of nursing. In 1901 New Zealand became the first country to enact a nursing licensing law, and other jurisdictions passed similar legislation over time. In 1903 North Carolina became the first state to enact a nursing practice act.

The time had also come for women practitioners to reclaim their territory by moving midwifery into the realm of regulatory standards and licensure. In 1881, Zepherina Veitch, a midwife who worked in the slums of London, helped to establish the Trained Midwives Registration Society. Its goal was to "raise the efficiency and improve the status of midwives and to petition parliament for their recognition." Despite significant opposition from doctors, by 1902 The Midwives Institute, as it was now called, successfully lobbied for the passage of an act that regulated the training and practice of midwifery. Standards gradually began to improve, and consequently midwifery became and continues to be an integral part of England's health care system.

In the late 19th century, women were also making progress into the allied health professions and the sciences. Sarah Tyson Rorer, who taught a course on diet for the sick at the Woman's Medical College in 1879, is credited with being America's first dietitian. A cookbook author and cooking teacher from Philadelphia, she added a special diet kitchen to her cooking school at the request of local doctors. The physicians sent in prescriptions for diets designed to address medical conditions, and Rorer would cook the food they requested. Some of the women who attended her cooking school went on to specialize in dietetics.

America's first female pharmacist was Mary Putnam, who graduated from New York College of Pharmacy in 1863. Putnam, who never practiced pharmacy, immediately enrolled in medical school and enjoyed a distinguished career as a physician and scientific writer under her married name, Mary Putnam Jacobi. Although their motivations were probably different from those that pro-

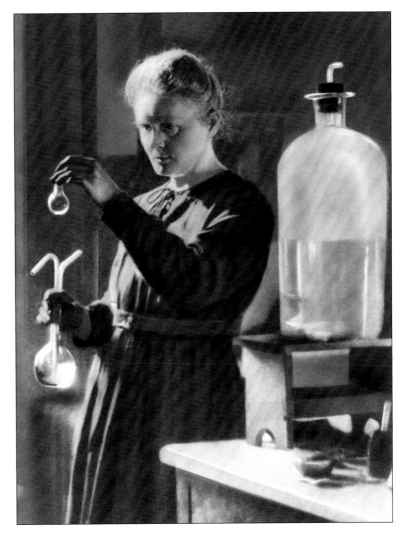

Marie Curie (1867–1934) in her laboratory, January 1905.

pelled Dr. Jacobi, a surprising number of women physicians also graduated from pharmacy schools in the late 19th century. In most cases, they did so as a practical necessity since male pharmacists often refused to fill prescriptions written by female doctors.

By the turn of the century, approximately 300 women had graduated from schools of pharmacy in the United States. Unfortunately, their degree did not guarantee entry into the profession. Like early women physicians,

they ran smack into additional obstacles. In some states, qualified women found themselves at odds with licensing boards that simply refused to register women. Others had difficulty completing their qualifications as male pharmacy owners wouldn't hire them for apprenticeship, thus denying them access to the requisite practical experience.

During this period, women were also making inroads into the sciences as well as health professions. For instance, by 1896, Marie Curie, who went on to become the first person to win two Nobel prizes, was beginning her experiments with uranium rays. Her work on radioactivity changed the face of science, but when World War I broke out, she was most interested in ensuring that her research was used for humanitarian purposes. Madame Curie knew that x-rays could save lives by quickly locating shrapnel and bullets in wounded men, so she turned her talents toward establishing x-ray vans that traveled to the front.

Like Madame Curie, numerous medical women made significant contributions to the great wars of the modern era, as doctors, nurses and ambulance drivers, among other roles. Canada introduced the idea of nursing sisters in 1885 when, for the first time, nurses joined the medical team dispatched to care for soldiers during the North-West Rebellion. Since then nursing sisters such as Georgina Fane Pope of Prince Edward Island have distinguished themselves in conflicts around the world. A graduate of nursing at Bellevue Hospital School of Nursing in New York City, Pope served in the Boer War, as well as in Britain and France during World War I.

Another illustrious volunteer to the Great War was pioneering Quebec physician Irma LeVasseur, who was sent to Serbia in 1915, where she worked day and night battling an epidemic of typhoid. When Serbia fell to the Germans,

Dr. LeVasseur, along with thousands of others, made the grueling walk over the Albanian mountains to a safe harbor on the Adriatic Sea.

Before volunteering her service in the war, Dr. LeVasseur was a trailblazer in the relatively new field of pediatrics. In 1907 she founded the Sainte-Justine's Children's Hospital in Montreal, one of the first hospitals devoted exclusively to the care of children. Montreal was home to another pioneer, whose career played a major role in pediatric medicine. Dr. Maude Abbott, who graduated from the Faculty of Medicine at Bishop's College in Montreal in 1894, was a scholar who blazed trails in the area of academic medicine. Her groundbreaking paper on cirrhosis was the first presented by a woman at the prestigious Pathological Society of London. Sir William Osler became a champion of her work and asked her to write the section on congenital heart disease for his *System of Medicine*. "I knew you would write a good article but I did not expect one of such extraordinary merit," he wrote after receiving her submission. "It is by far and away the very best thing ever written on the subject in English – possibly any language … For years it will be the standard work on the subject."

Dr. Abbott's reputation extended beyond Canadian borders, and in 1938 she was approached by Dr. Helen Taussig, the pediatrician in charge of the pediatric cardiology division at Johns Hopkins School of Medicine. Using Dr. Abbott's work on congenital heart disease in children as a basis, Dr. Taussig and her associates went on to develop the first successful operation to save so-called "blue babies," those previously doomed to certain death from oxygen deprivation because not enough blood could reach their lungs. Dr. Taussig went on to become an internation-

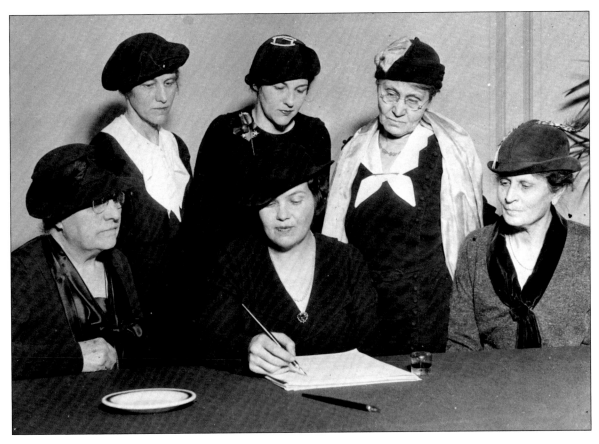

Members of the American Birth Control League at the fourteenth annual meeting, Chicago, January 1935.

ally recognized pediatric cardiologist and was appointed a professor of pediatrics at Johns Hopkins in 1959.

By the turn of the century, when Dr. Abbott was delivering her first research papers and her career was well on its way, many other determined women throughout the world were also beginning to make their mark on medicine. Karen Horney, who was among the first women admitted to medical school in Germany, became a pioneering psychoanalyst in Berlin. After immigrating to the United States, she did groundbreaking work on the psychology of women, challenging many of the sexist stereotypes that influenced the work of her male colleagues. In 1952 Virginia Apgar, an American anesthesiologist, developed the Apgar system, which is still used to evaluate the health of newborns. Dr. Mary Ellen Avery, like many of her contemporaries, enjoyed an illustrious career of firsts. For instance, when she was appointed Chief of Medicine at Children's Hospital in Boston in 1974, she became the first woman to fill that position at a Harvard teaching hospital.

In fact, there have been so many outstanding women physicians over the past hundred years that it would be virtually impossible to compile a complete list of those who distinguished themselves. Placed in perspective – throughout this period women were a minority of physicians – their collective achievement becomes even more impressive. Clearly, a small number of women made an enormous contribution to modern medicine.

The same holds true for community health, an area

where nurses as well as doctors have made their mark. For instance, at the turn of the century, Canada's Victorian Order of Nurses (VON) brought urgently needed medical care to the remote areas of the country. The women who formed the VON, under the auspices of Lady Aberdeen, the wife of the governor general, did so over the strenuous objections of a segment of society who were appalled at the idea of trained and independent women traveling to distant locations. In 1897, almost immediately after being granted its royal charter, the Order's first superintendent, Charlotte McLeod, led a team of nurses to the Klondike to supply medical services for the thousands of men who had rushed to the area in the heat of the gold rush. Since then the VON has pioneered many health care services in the community such as home care and school health services.

The VON is just one of many nursing-driven organizations that have played major roles in the advancement of public health. Working together, women doctors and nurses introduced innovations such as well-baby clinics and lobbied for public health reforms that helped to lower the infant mortality rate. The well-being of families, primarily women and children, was often at the forefront of their concerns. Recognizing the connection between poor health, poverty and large families, birth control pioneers such as Dr. Marie Stopes in England and public health nurse Margaret Sanger in the United States led the battle to have contraception legalized. And trailblazers such as Dr. Marion Powell, who made history when she helped to launch Canada's first municipally funded family planning clinic in 1966, and Dr. Mary Steichen Calderone, America's "grandmother of sex education," were often publicly pilloried for providing people with the information and tools they needed to be sexually responsible.

Women in medicine have come a long way since Florence Nightingale set out for the Crimea and Elizabeth Blackwell earned her M.D. degree. Today, women constitute almost 50 percent of the students at faculties of medicine and pharmacy and they can be found in every medical specialty. Over 90 percent of nurses are female. One hundred fifty years is a relatively short period in the great scheme of things; but during that time the world has undergone extraordinary changes, and health care has felt the impact. High-tech machinery and drugs, complex surgical procedures and dramatic increases in life expectancy throughout the developed world, while positive developments in themselves, have introduced new challenges to health care, such as managing chronic illness and caring for an aging population.

While vestiges of discrimination still exist, today's medical women face different challenges than the pioneers of previous generations. Their right to be professionals may be taken for granted, but most combine employment with families and community involvement, which makes the issue of work-family balance a predominant concern. One result is that decision-making about where to practice and what specialty to choose is complicated for women, who are more likely to assume homefront responsibilities than their male colleagues. Women physicians are more likely to weigh their choices in the context of how they will affect the equilibrium between career and family life. For instance, research shows that women are more likely to choose specialties in areas like family medicine, pediatrics or psychiatry because they can work more regular hours during their child-rearing years.

When student nurses entered the Mack Training School for Nurses in St. Catharines, Ontario, which opened in

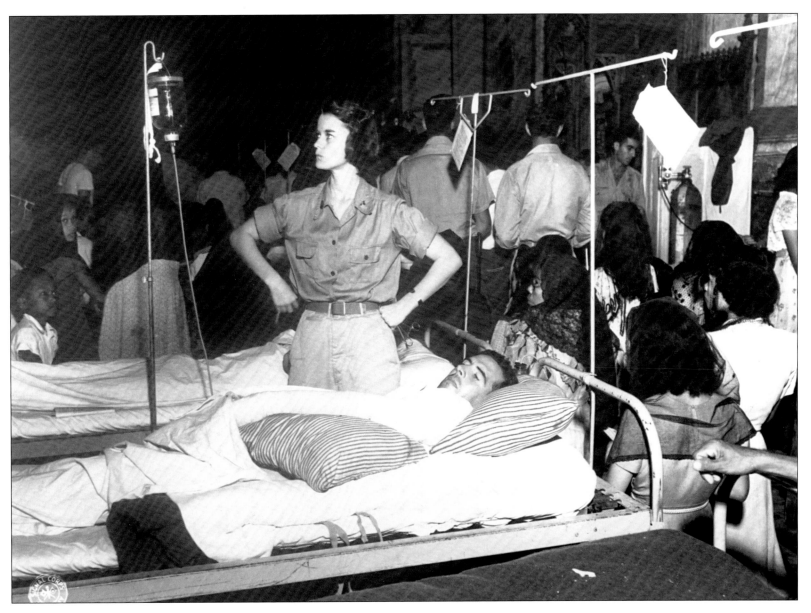

Church doubling as evacuation hospital, Philippine Islands, December 1944.

1874, their preferred attitude was captured in the school's motto: "I see and I am silent." In the past, nurses were cast, often unwillingly, in the role of physician's handmaiden. Today that is no longer the case. Nurses are, by necessity, highly skilled, well-educated professionals who draw on a wide body of knowledge and experience to perform their work. The increased demands of a cost-conscious and dramatically changing health care environment ensure that all health care professionals are active and crucial contributors to quality care. Financial cutbacks and innovations such as day surgery mean that patients who remain in the hospital are likely to be sicker

than they were in the past. And although complex surgery saves the lives of people who might have died years ago, their post-operative care demands a wider range of skills involving science and technology, as well as hands-on care.

And yet, as our health care institutions become increasingly driven by complex systems and machines, the personal touch remains a fundamental component of medicine. To repeat Osler's defining thought: "The practice of medicine is an art, not a trade; a calling, not a business, a calling in which your heart will be exercised equally with your head." This is the elusive aspect of medicine that is so elegantly captured in Ted Grant and Sandy Carter's evocative photographs of contemporary women working in health care. The images reflect a series of people: physicians and surgeons, nurses and technologists and many others, compellingly involved with a variety of individuals who range widely in age and degree of infirmity. Even when a photograph portrays a solitary subject – for instance, a home health care provider filling up a syringe in a patient's kitchen – the picture telegraphs the sense of connection that lies at the heart of care. Certainly the subjects are skilled professionals who base their treatment on extensive knowledge and training. But viewed as a series, the photographs also reveal a network of concerned human beings responding to profound human needs, the heart and soul of medicine itself.

JUDITH FINLAYSON

A PHOTOGRAPHIC TRIBUTE

Ted Grant & Sandy Carter

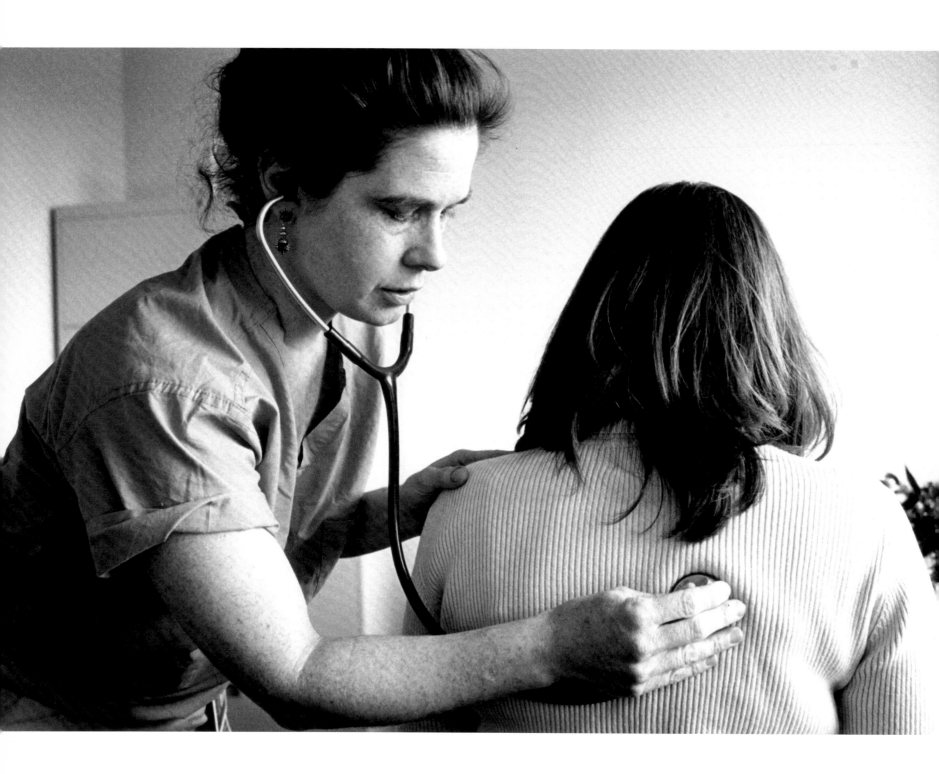

We must believe in ourselves ... we must match

our aspirations with the competence,

courage and determination to succeed.

ROSALYN SUSSMAN YALOW (1921–)

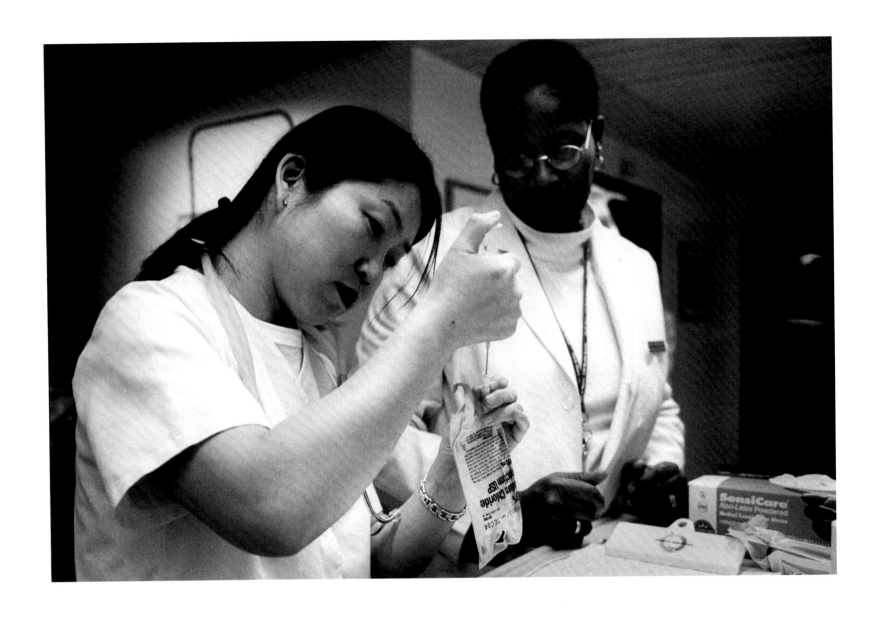

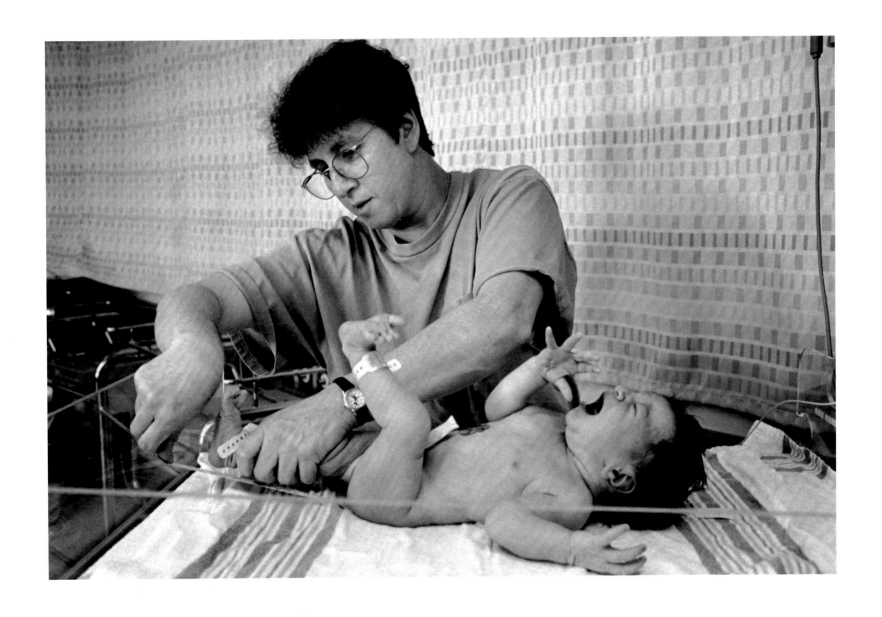

All things are possible until they are proved impossible
– and even the impossible may only be so, as of now.

PEARL BUCK (1892–1973)

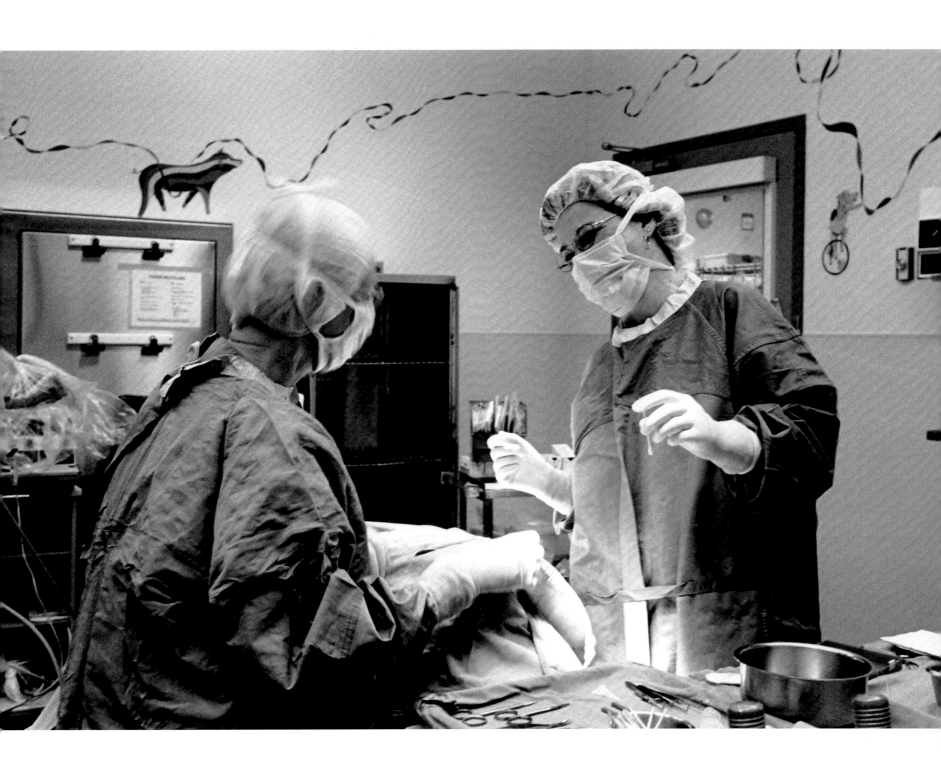

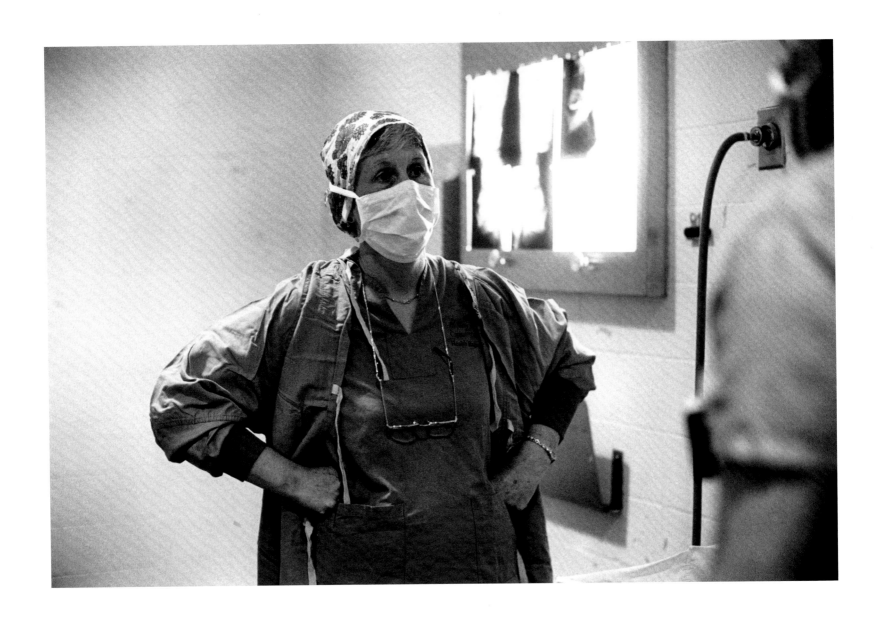

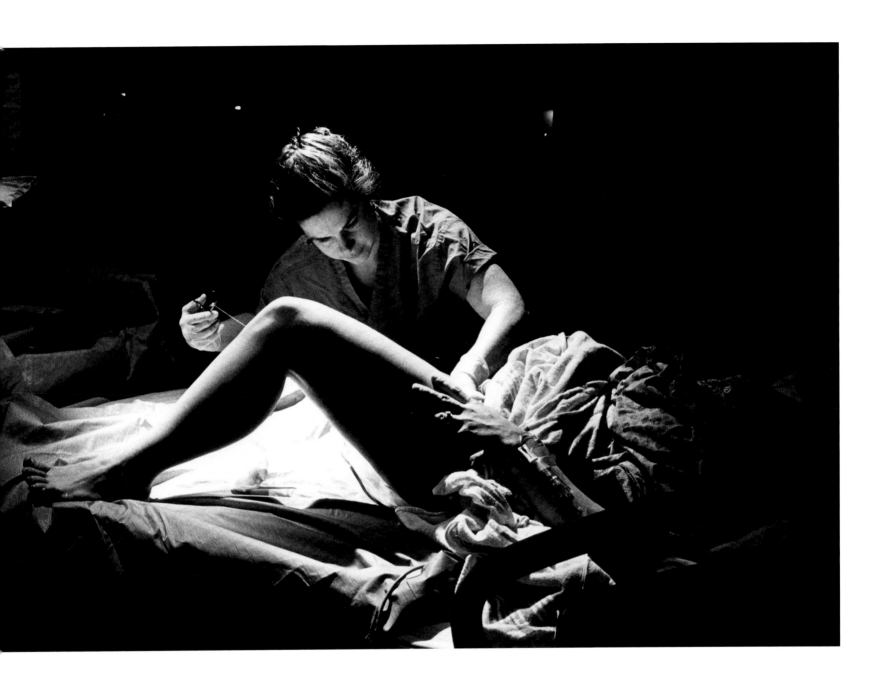

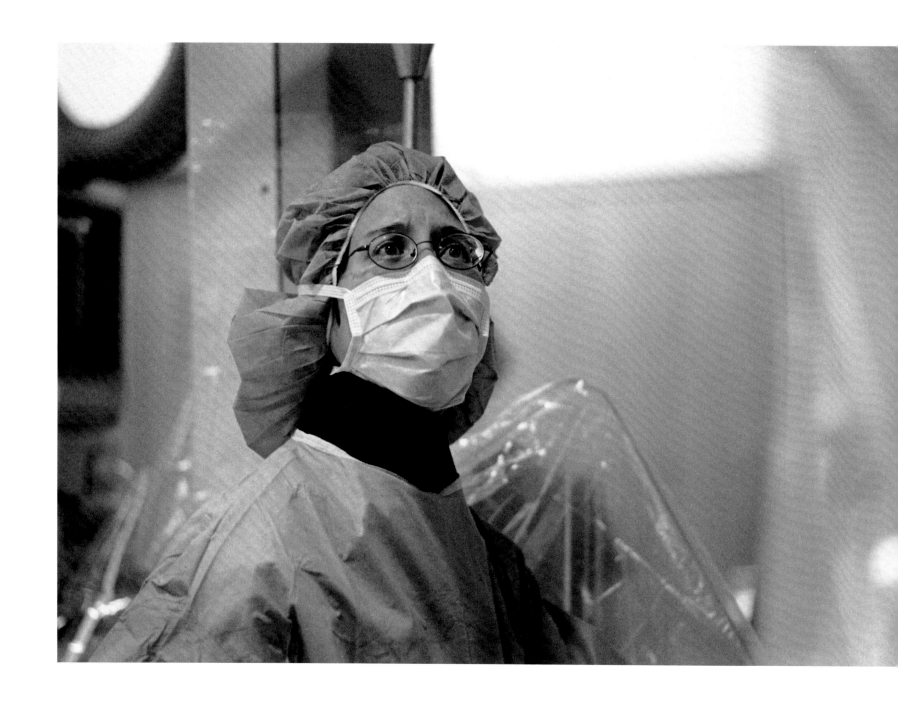

Medicine is the most humane of the sciences

and the most scientific of the humanities.

UNKNOWN

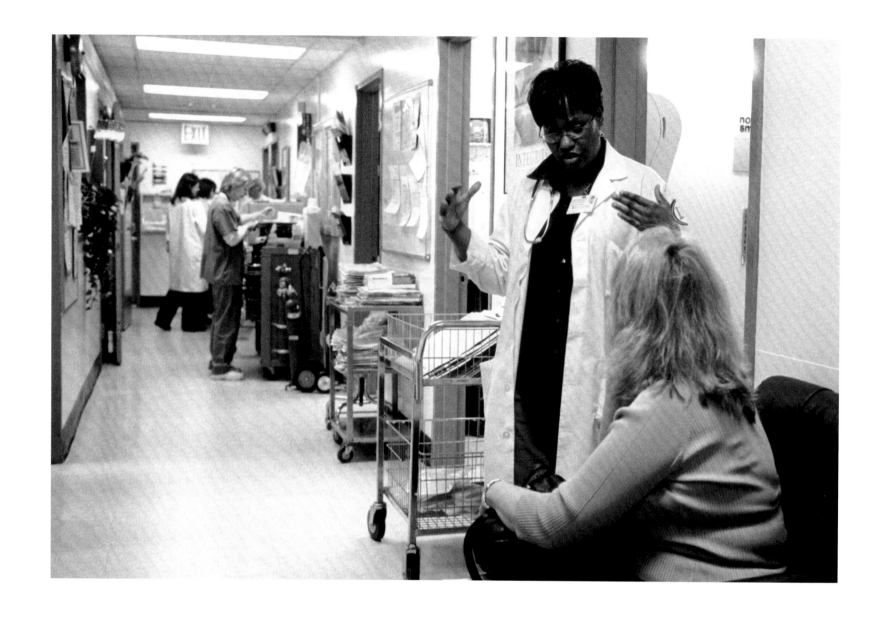

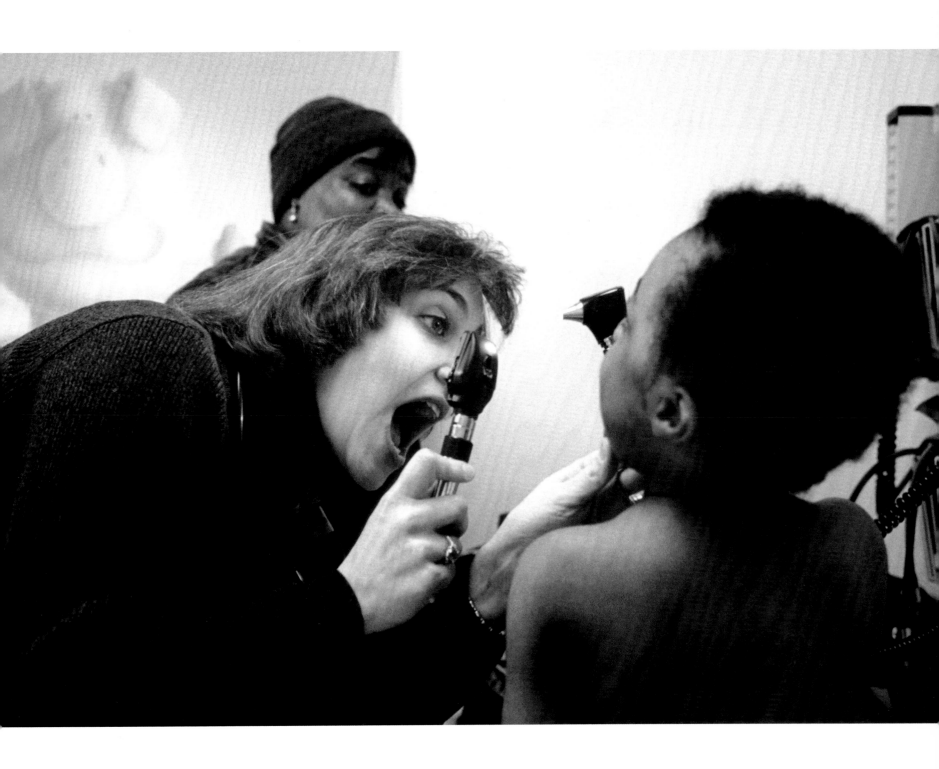

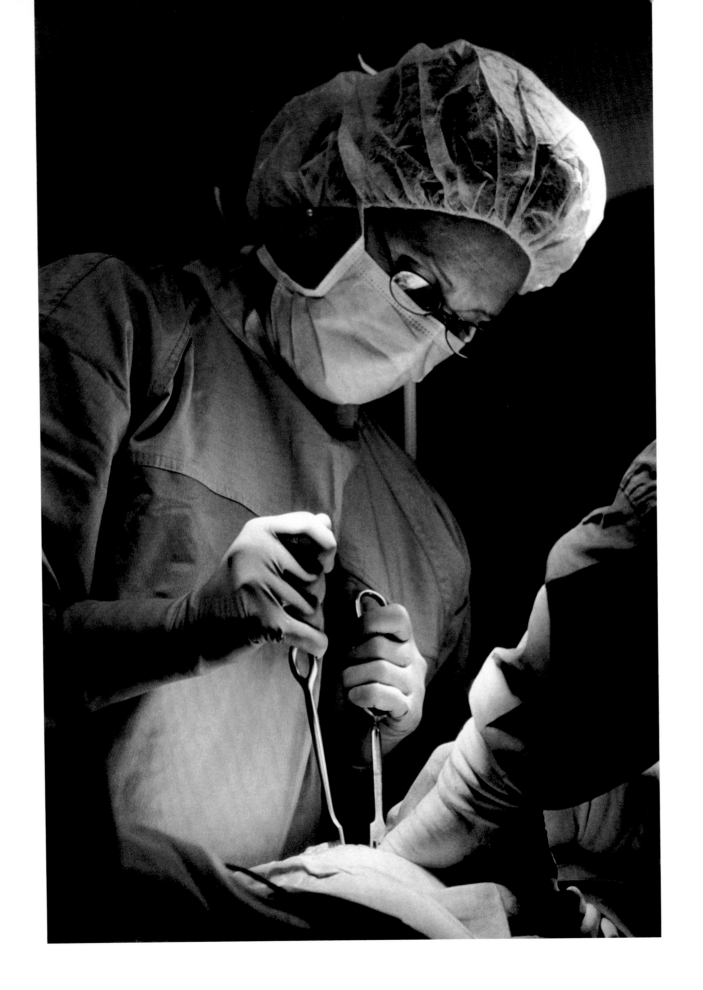

Men and women are like right and left hands;
it doesn't make sense not to use both.

JEANNETTE RANKIN (1880–1973)

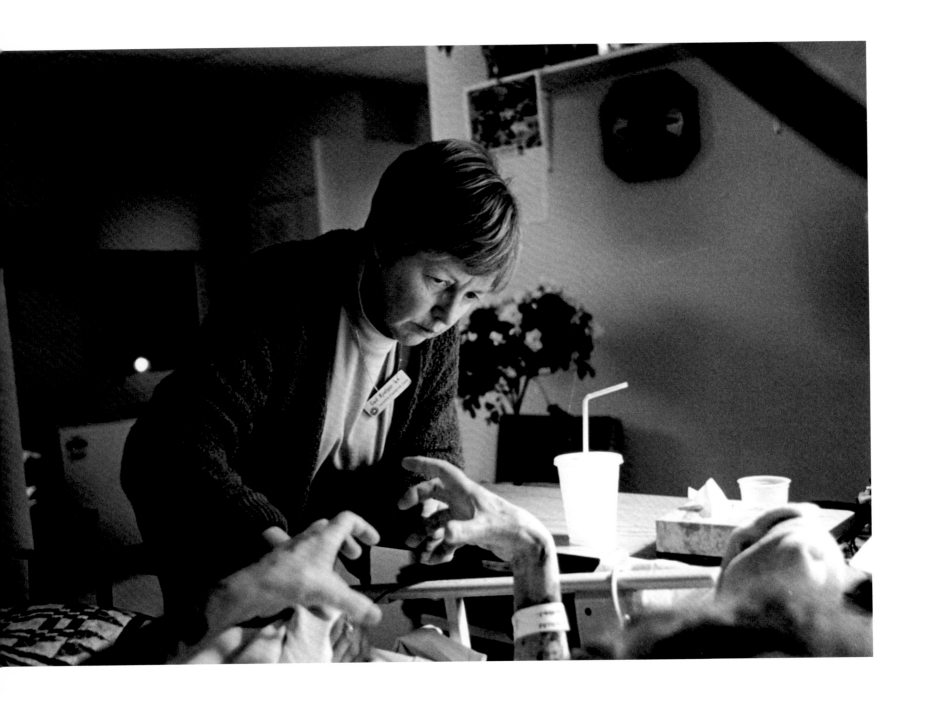

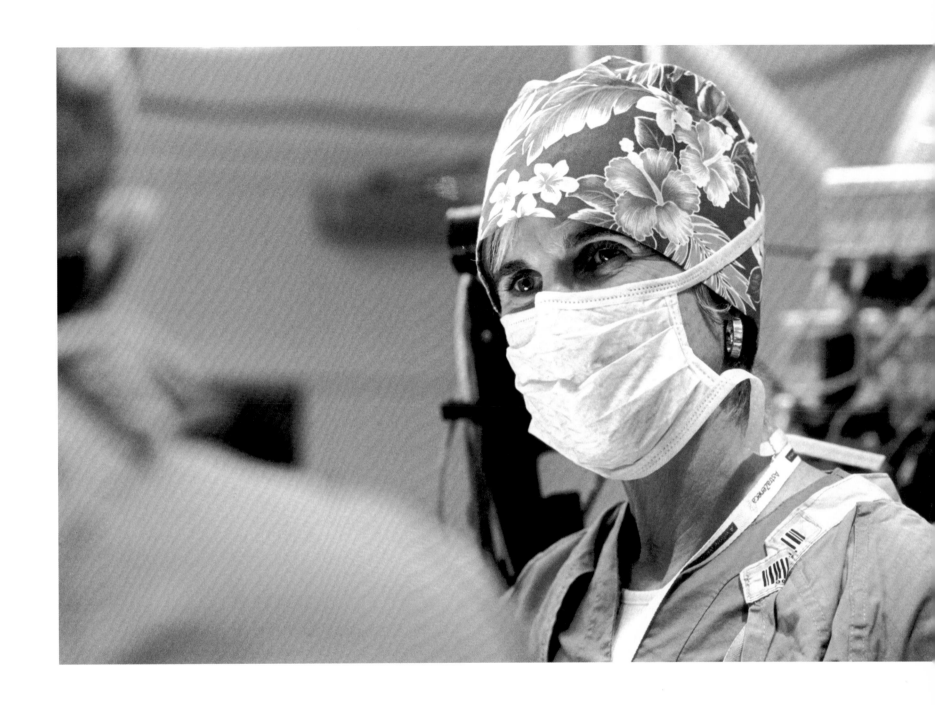

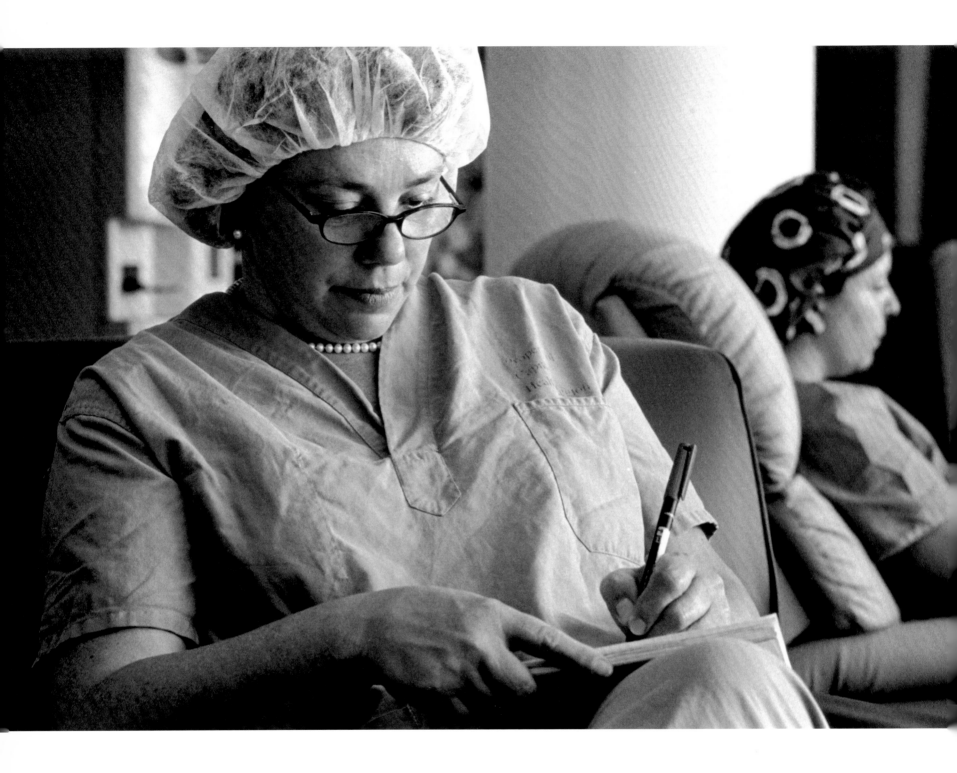

Leadership should be born out of the understanding of the needs of those who would be affected by it.

MARIAN ANDERSON (1897–1993)

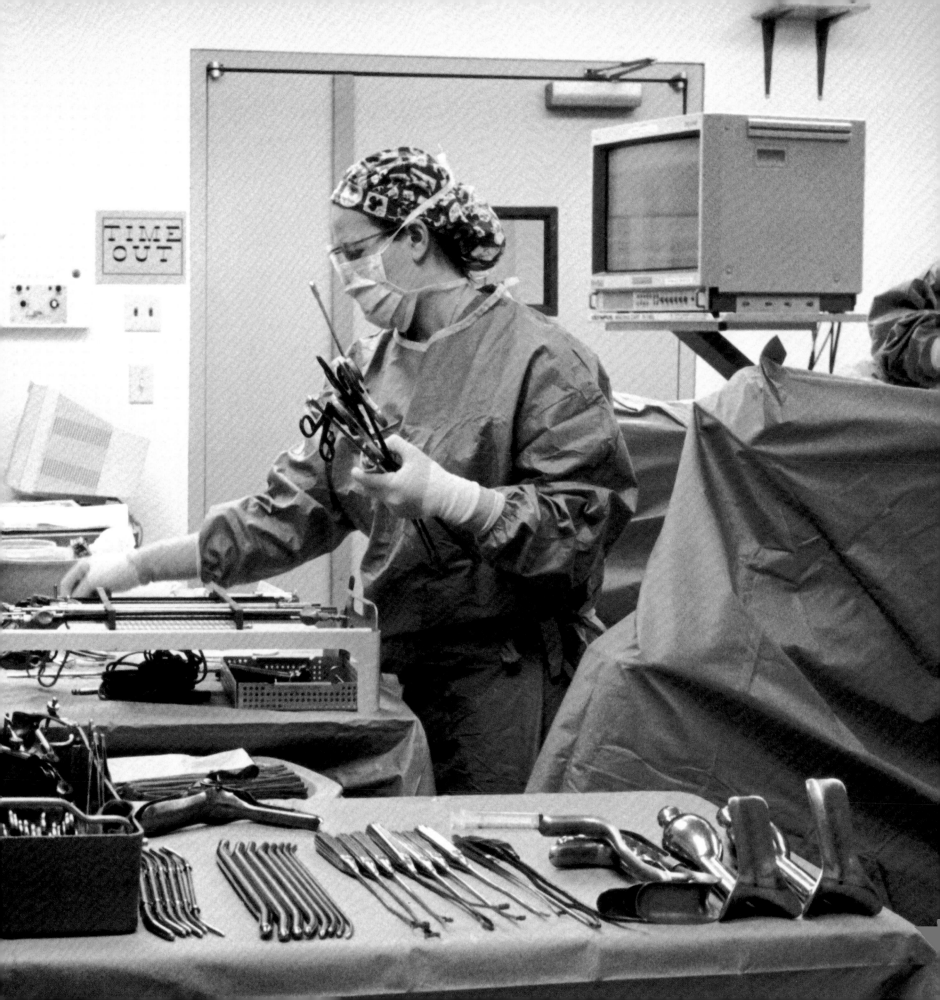

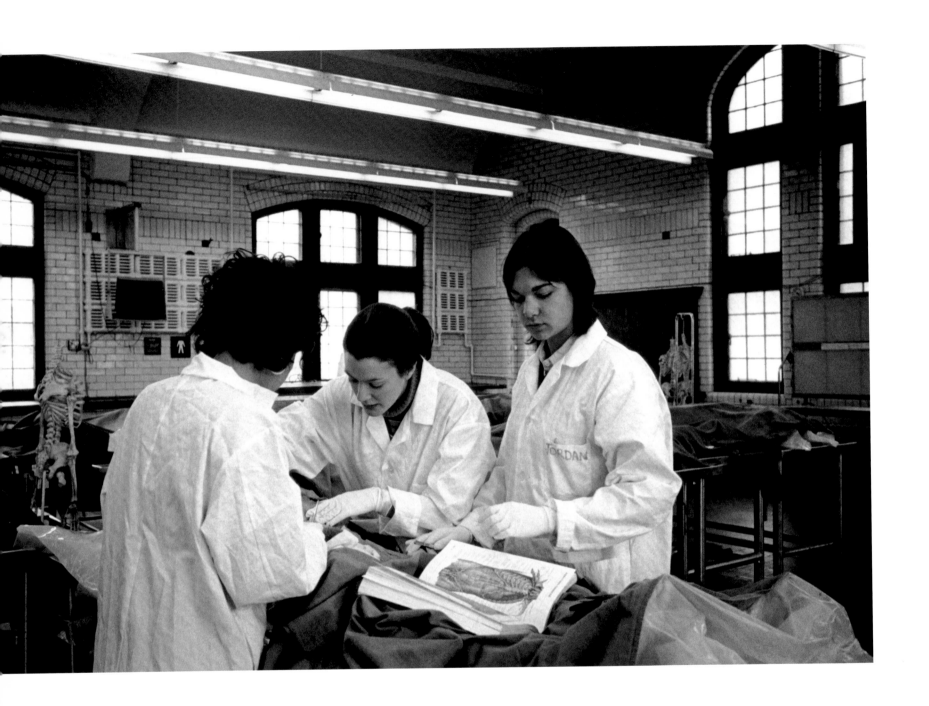

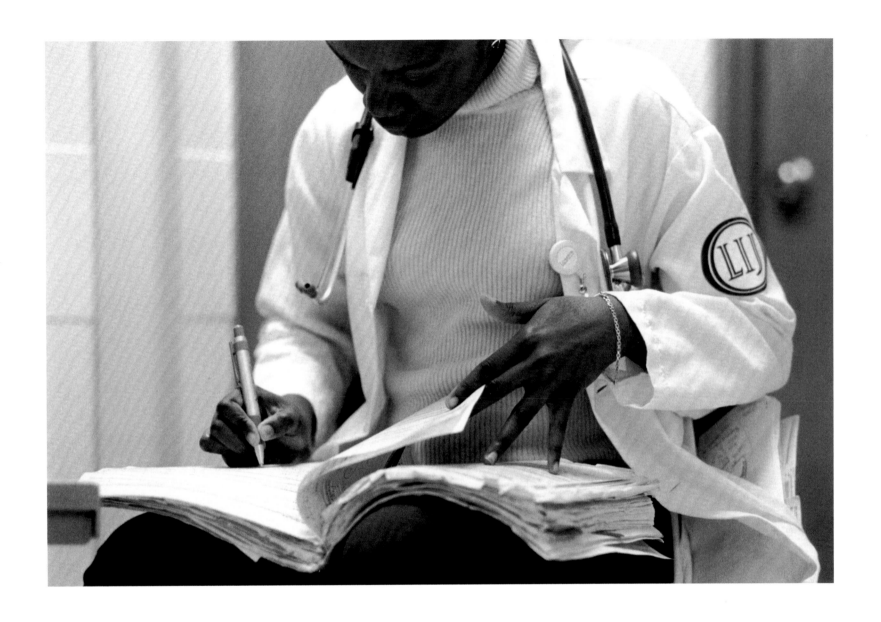

We saw no reason why women should not be

the medical attendants of women …

UNKNOWN

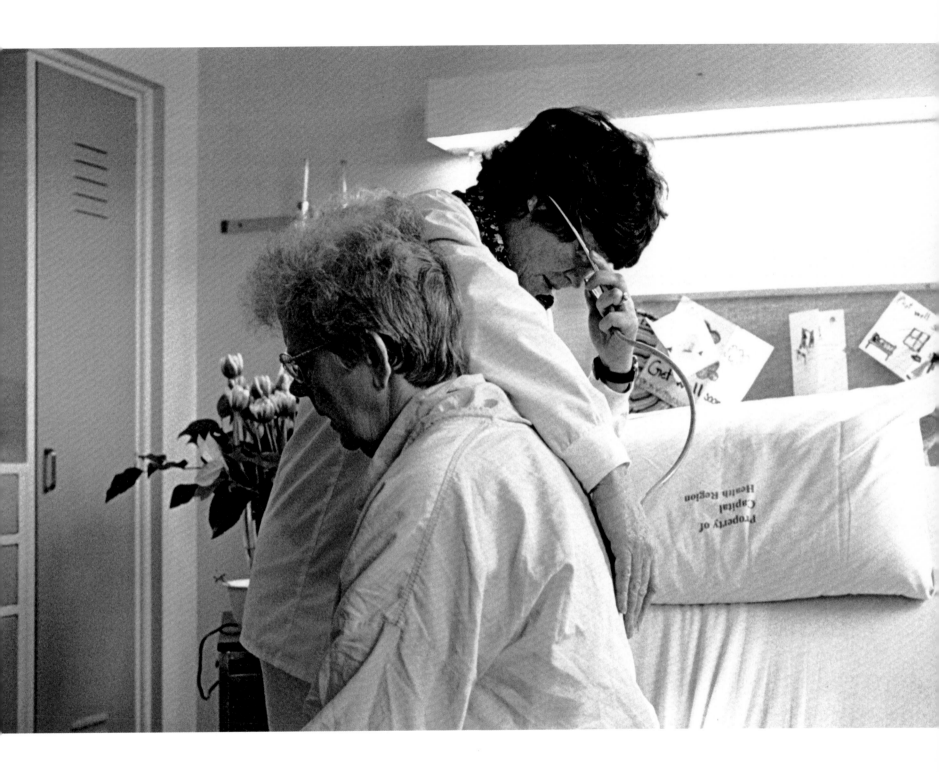

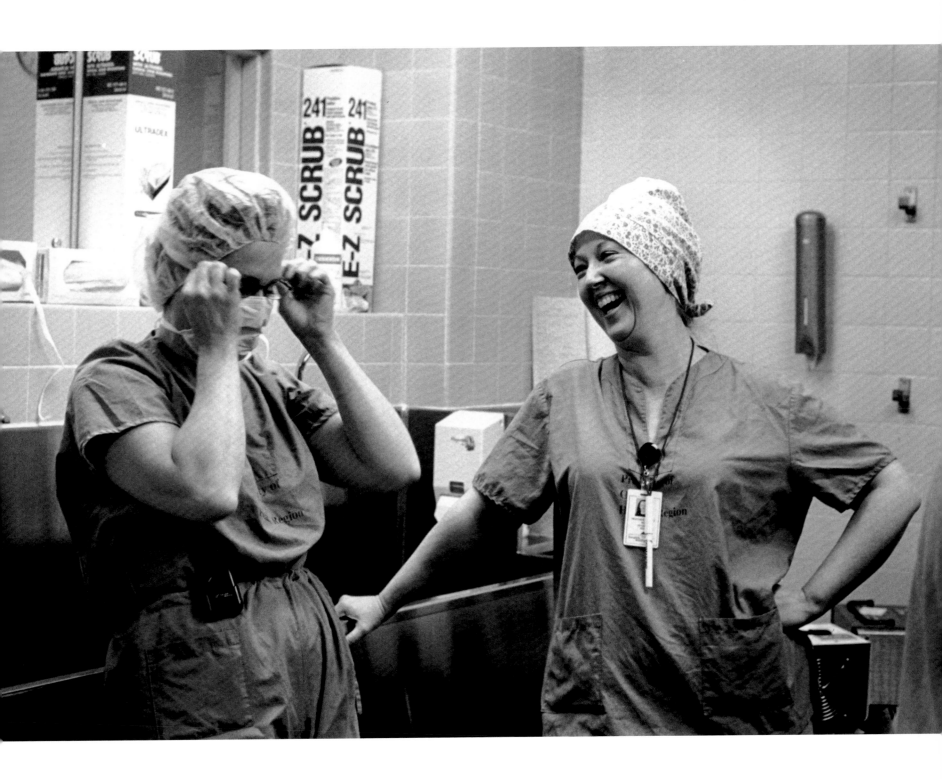

Women learned the healing art by doing, while men by reading about it. The actual care of the sick was largely in the hands of women; and still is.

MARCIA RAMOS-E-SILVA

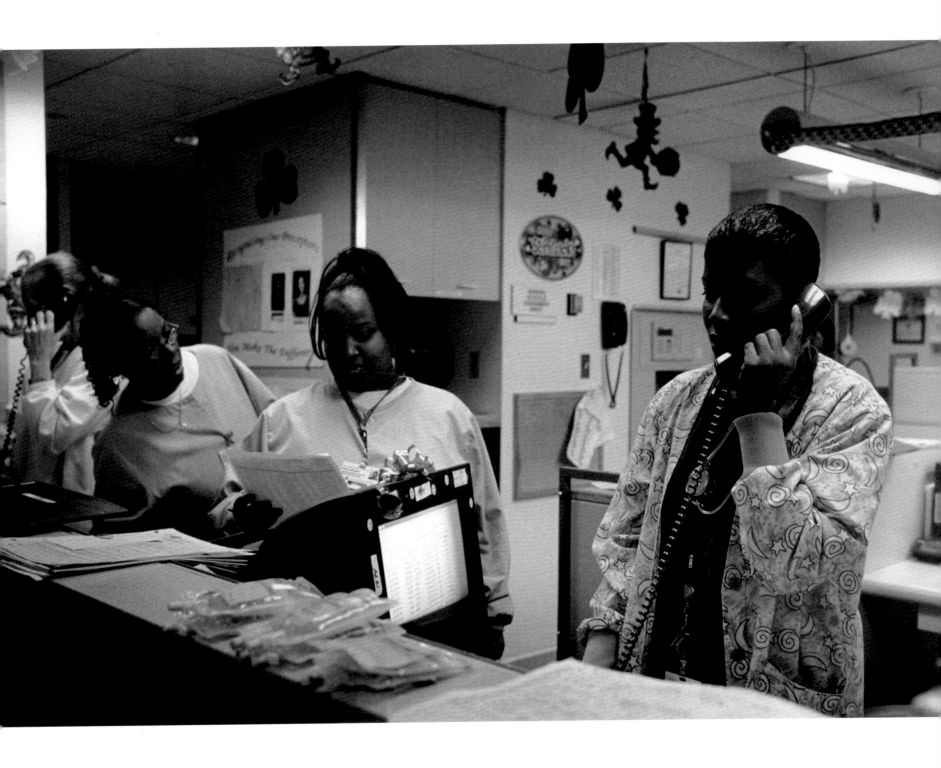

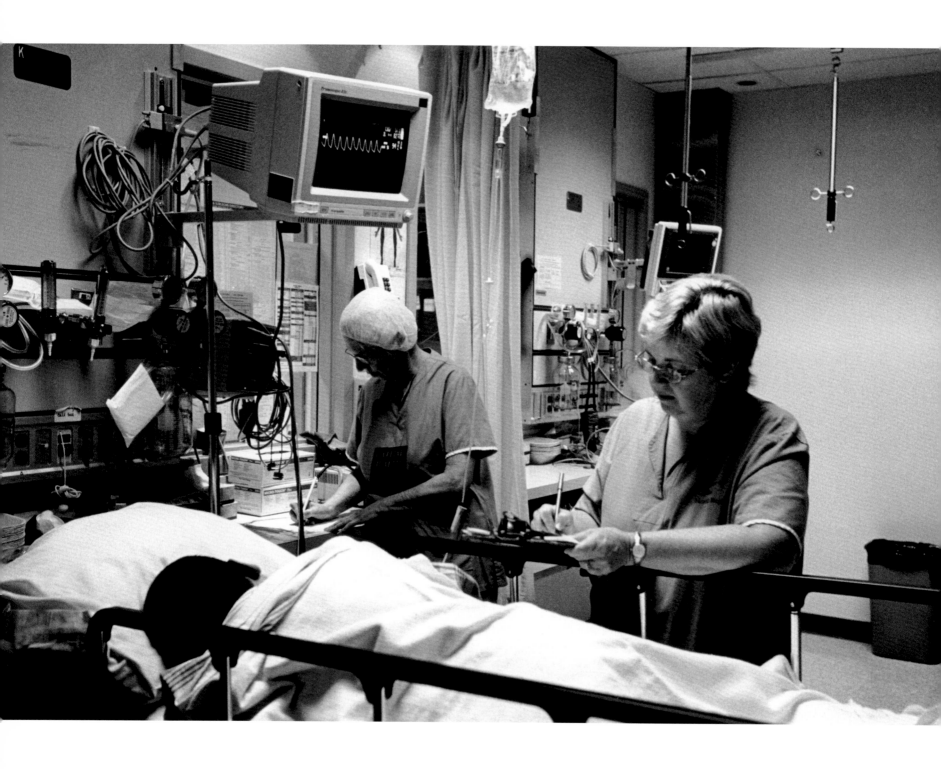

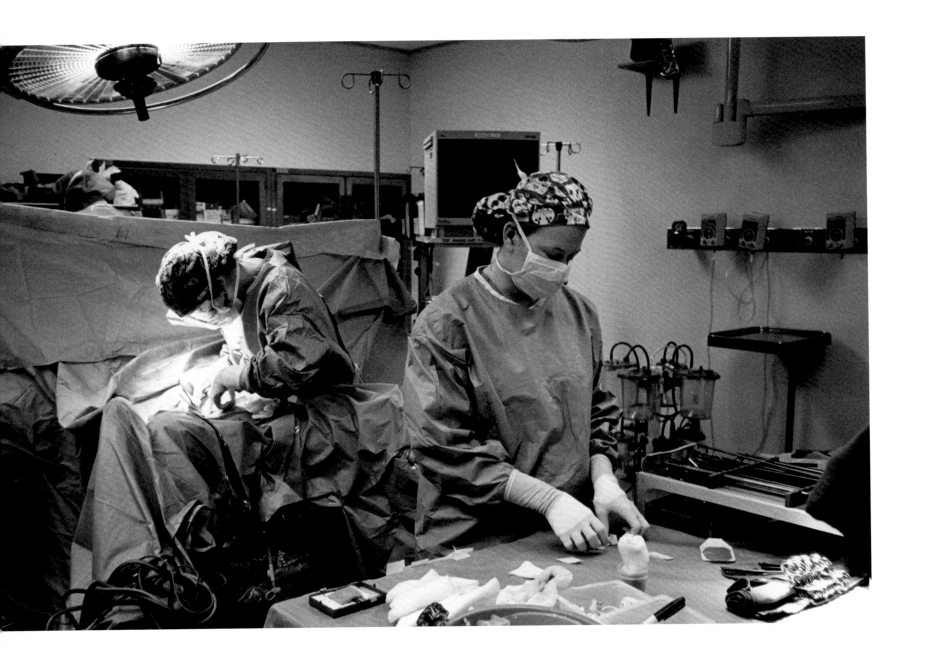

I think one's feelings waste themselves in words;
they ought all to be distilled into actions
which bring results.

FLORENCE NIGHTINGALE (1820–1910)

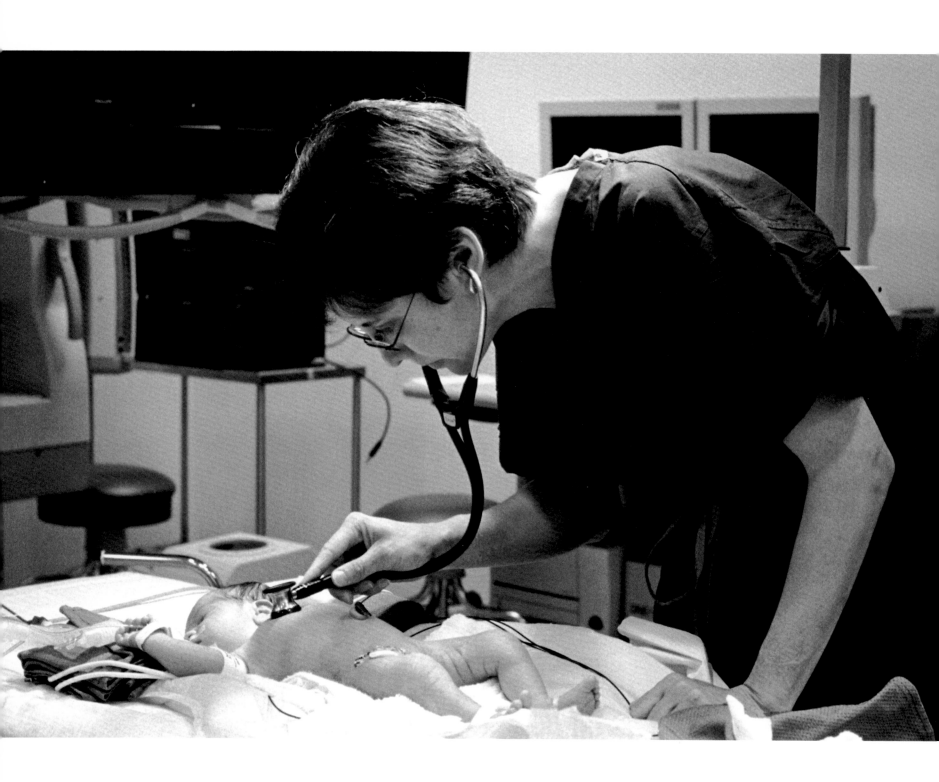

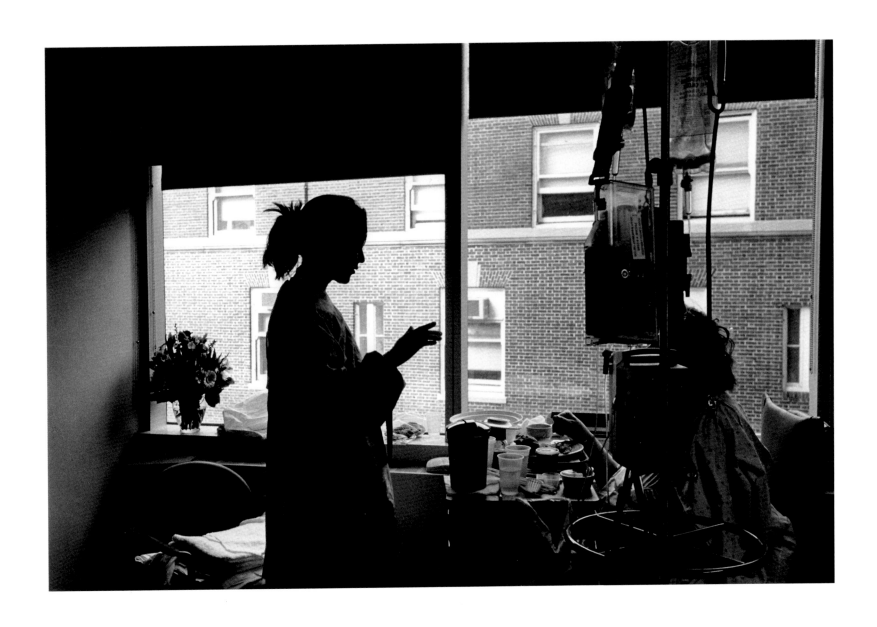

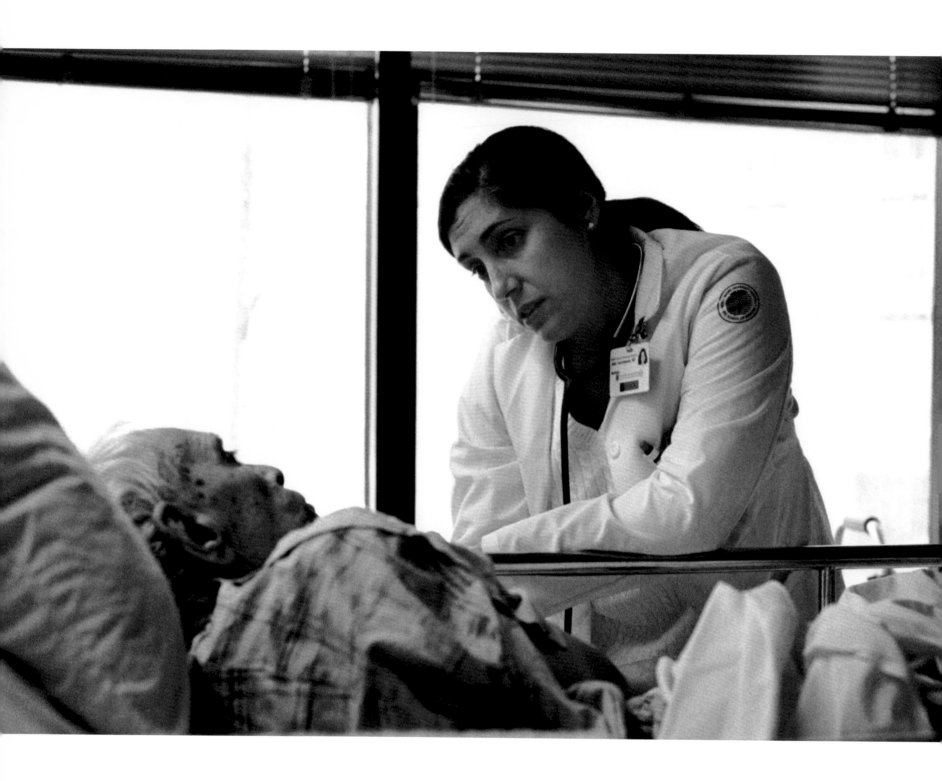

You have not lived a perfect day, even though you have earned your money, unless you have done something for someone who will never be able to repay you.

RUTH SMELTZER (1961–)

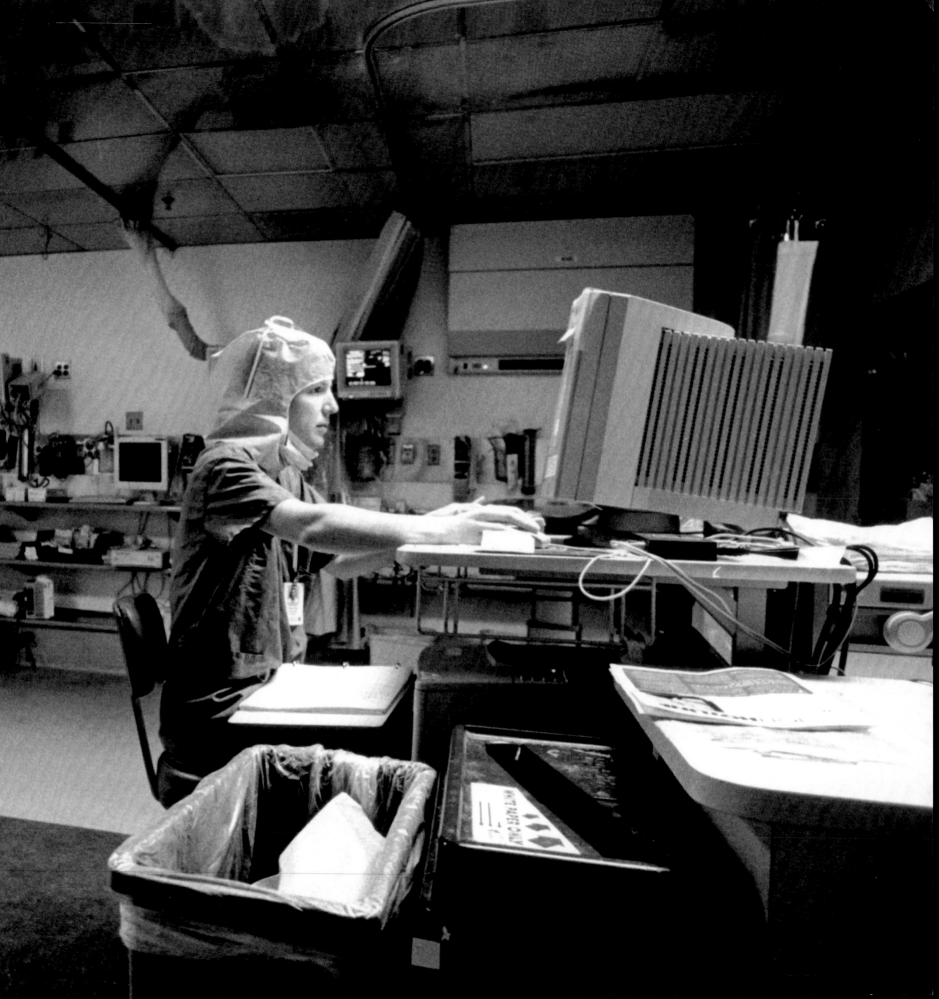

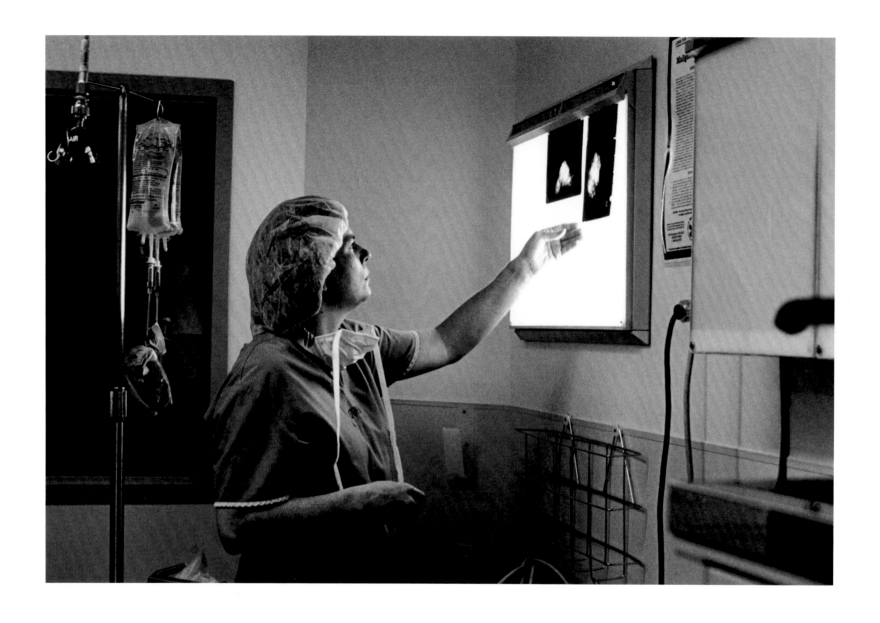

Thousands upon thousands of persons have studied disease. Almost no one has studied health.

ADELLE DAVIS (1904–1974)

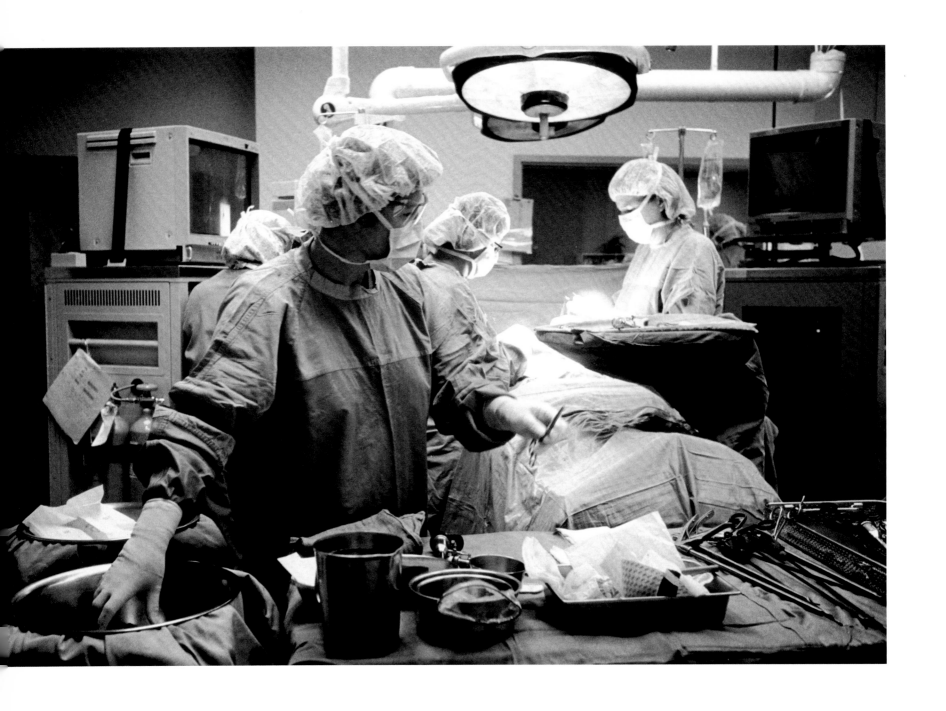

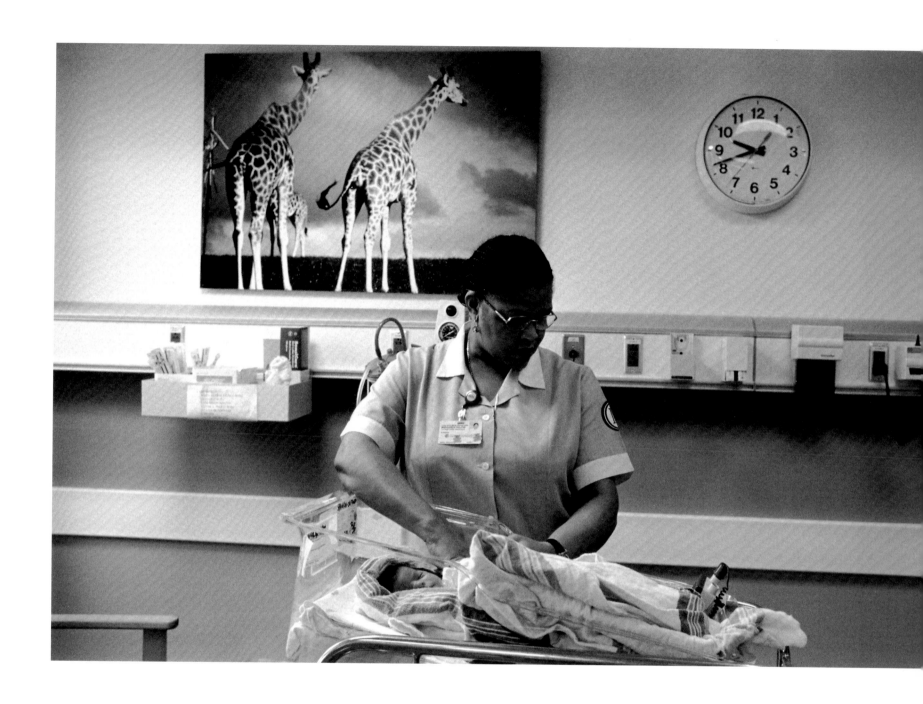

One never notices what has been done;
one can only see what remains to be done.

MARIE CURIE (1867–1934)

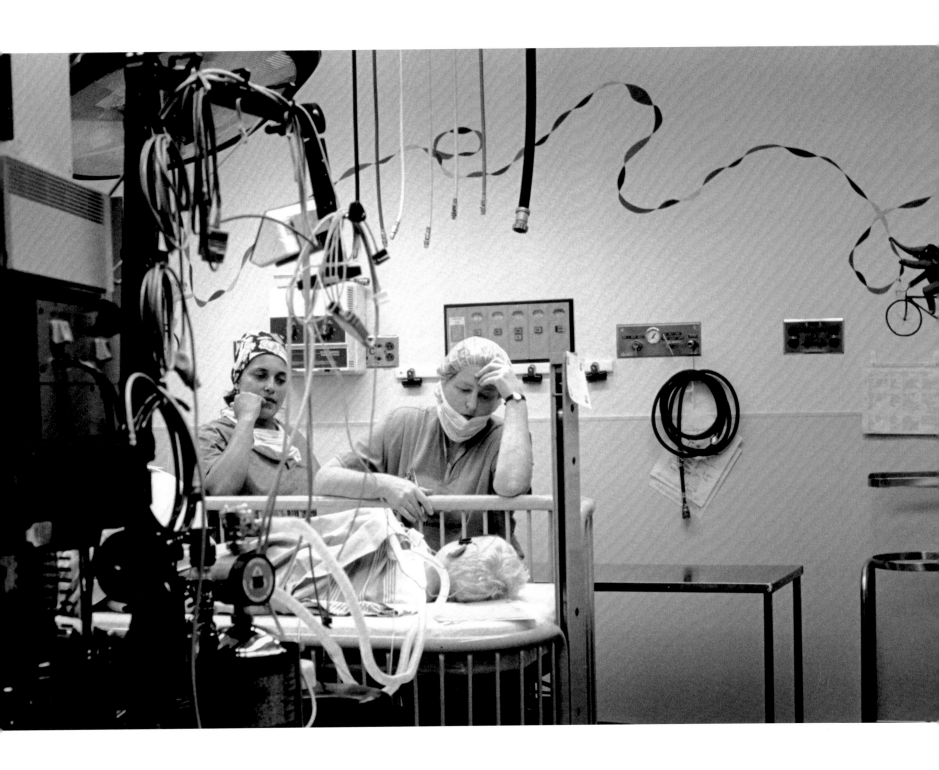

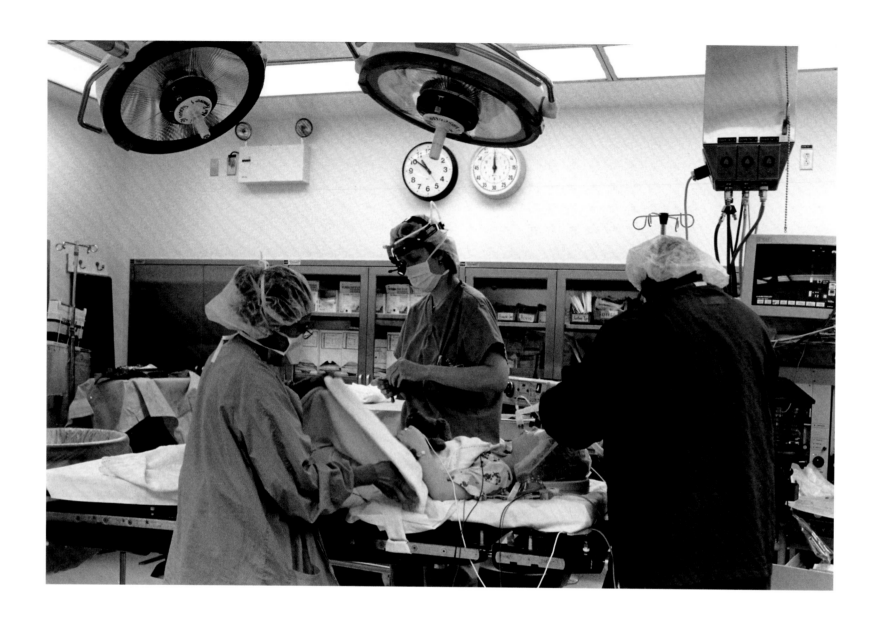

The question is not whether women, as a class,
are as strong as men, but whether they possess
the strength necessary to become efficient practitioners.
In view of the facts of the past and the present,
I can have no doubt they are.

WILLIAM H. BYFORD (1817–1890)

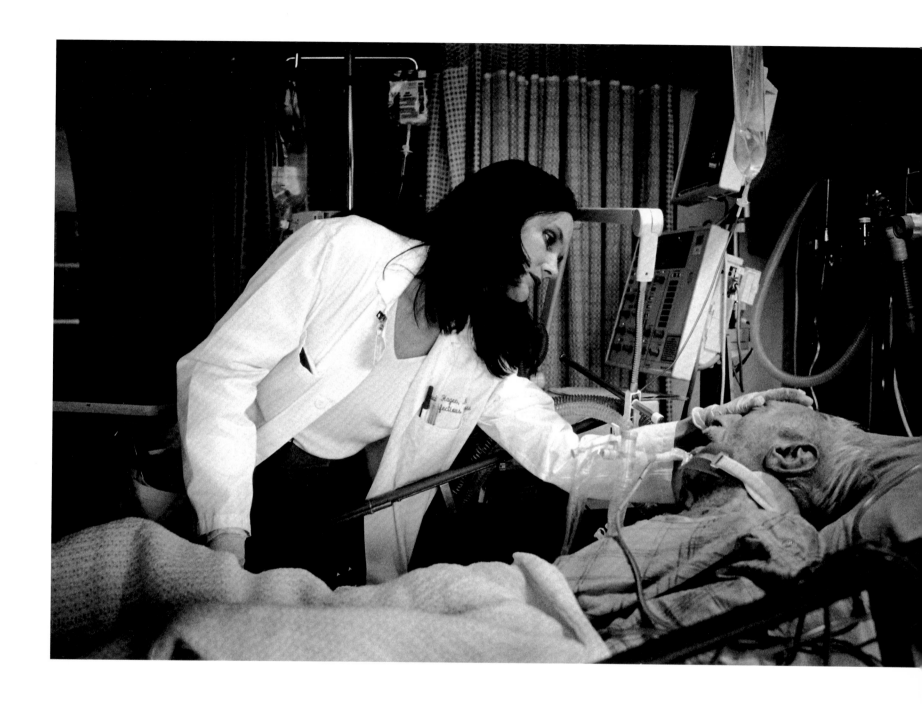

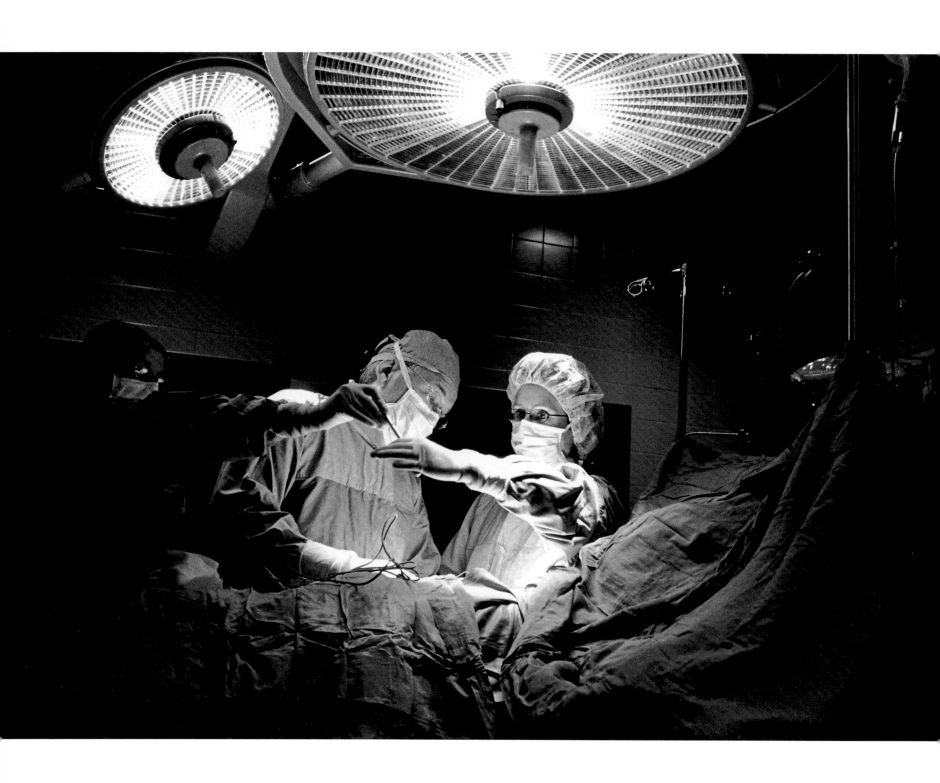

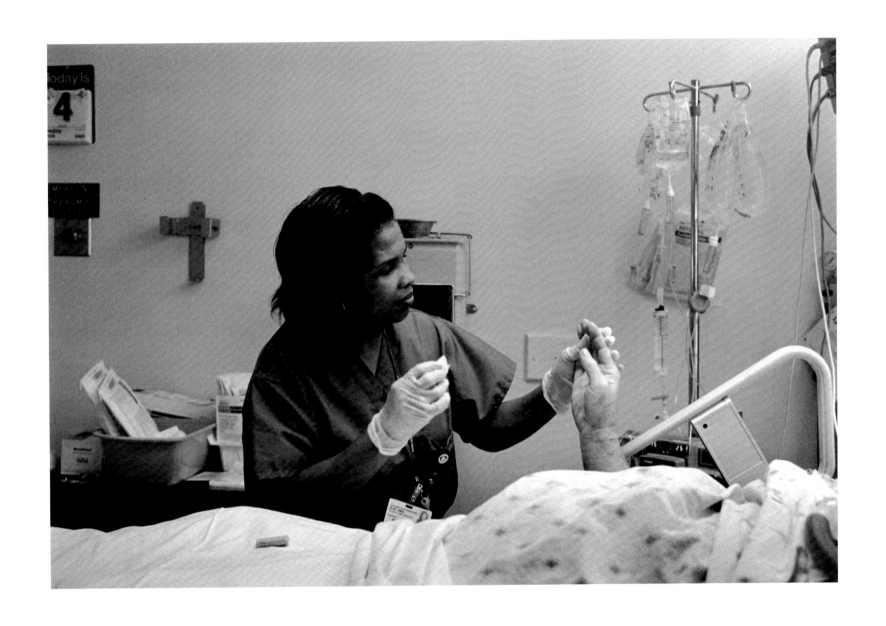

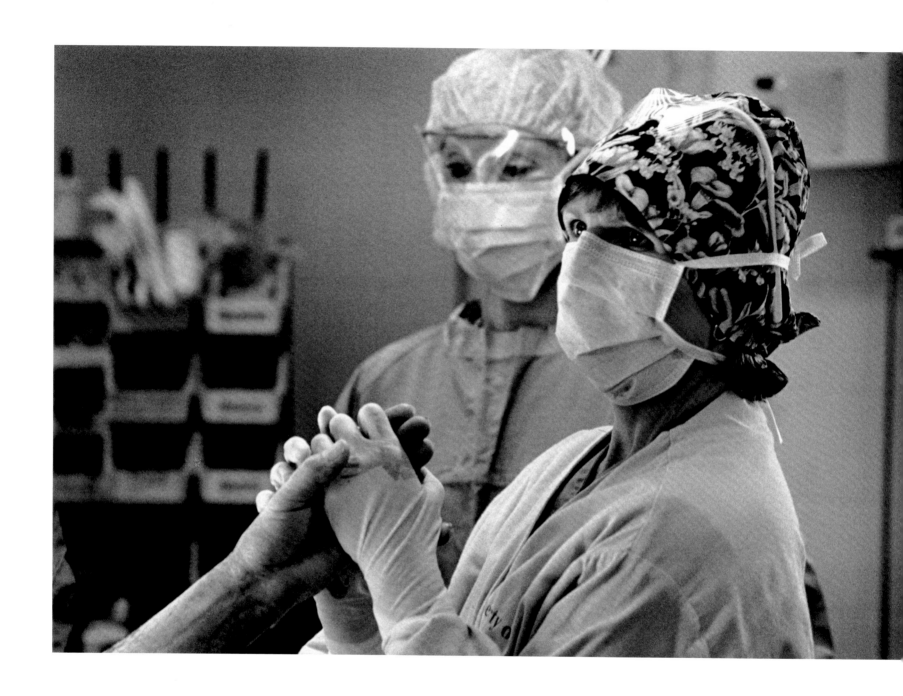

Character cannot be developed in ease and quiet.
Only through experience of trial and suffering
can the soul be strengthened, ambition inspired,
and success achieved.

HELEN KELLER (1880–1968)

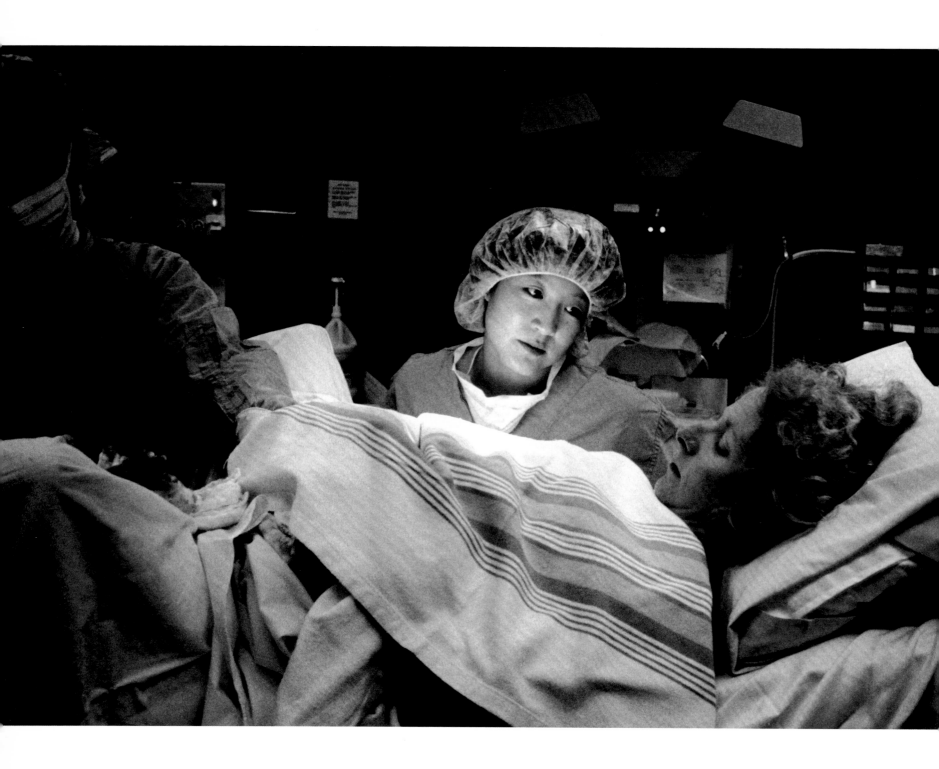

For what is done or learned by one class of women becomes, by virtue of their common womanhood, the property of all women.

EMILY BLACKWELL (1826–1910)

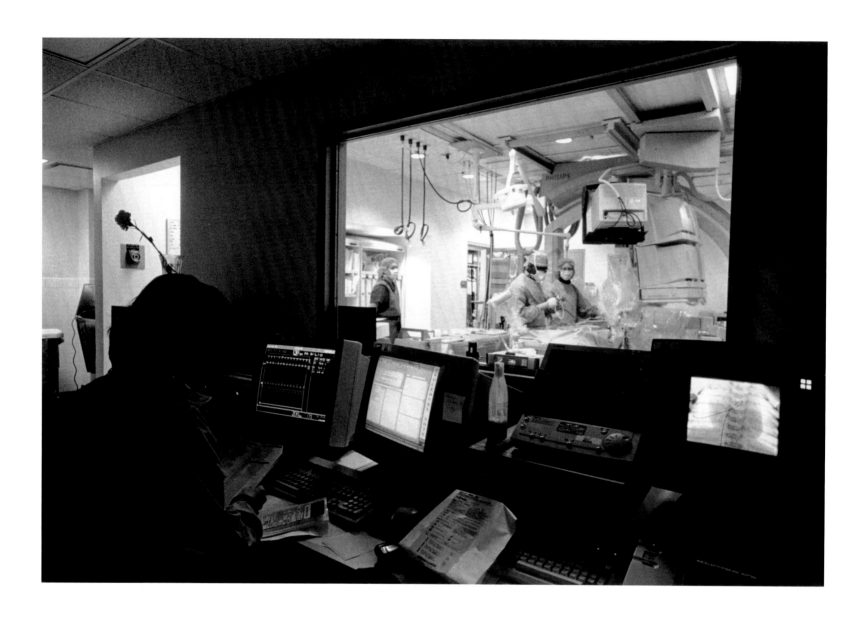

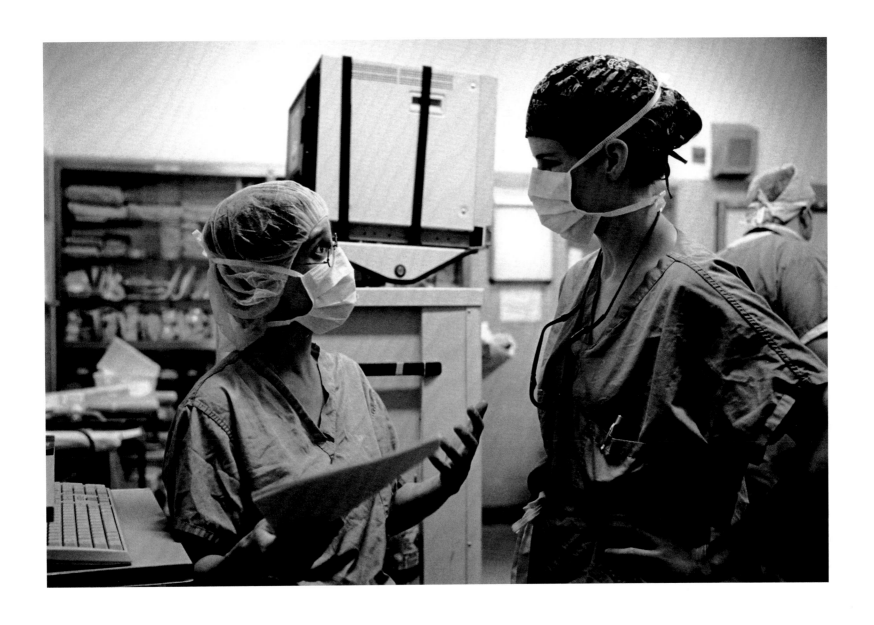

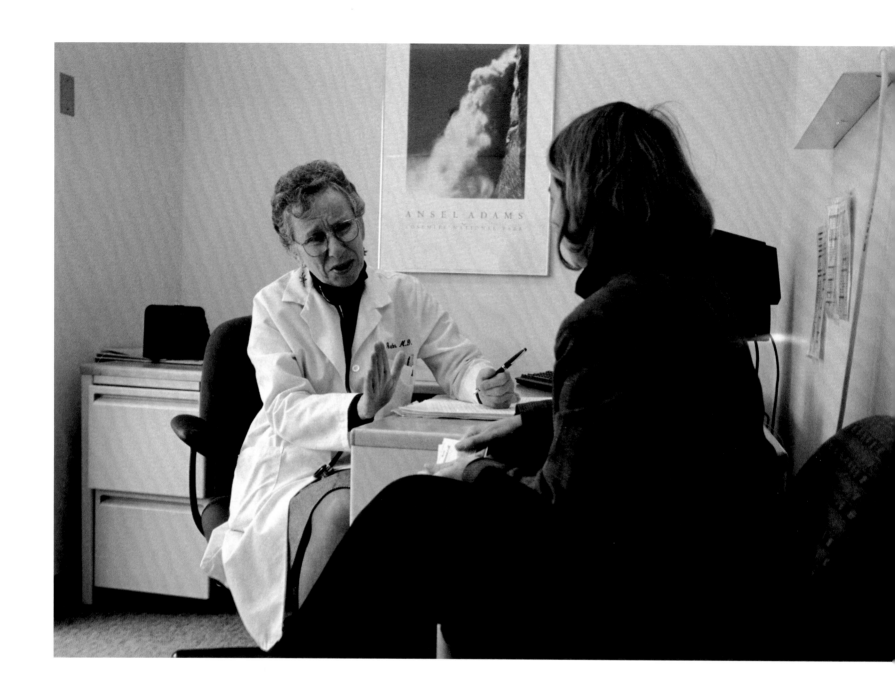

The American doctor possesses a combination of conservatism and an eagerness to know what it is really all about, in order that he may not be the one left behind if there is something to it.

ELIZABETH KENNY (1886–1952)

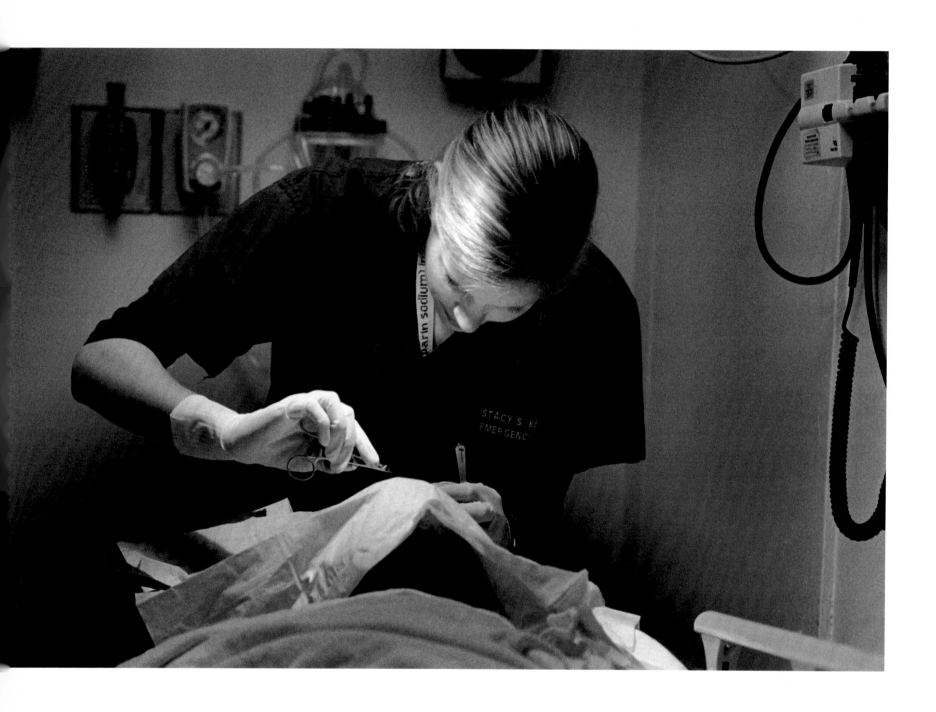

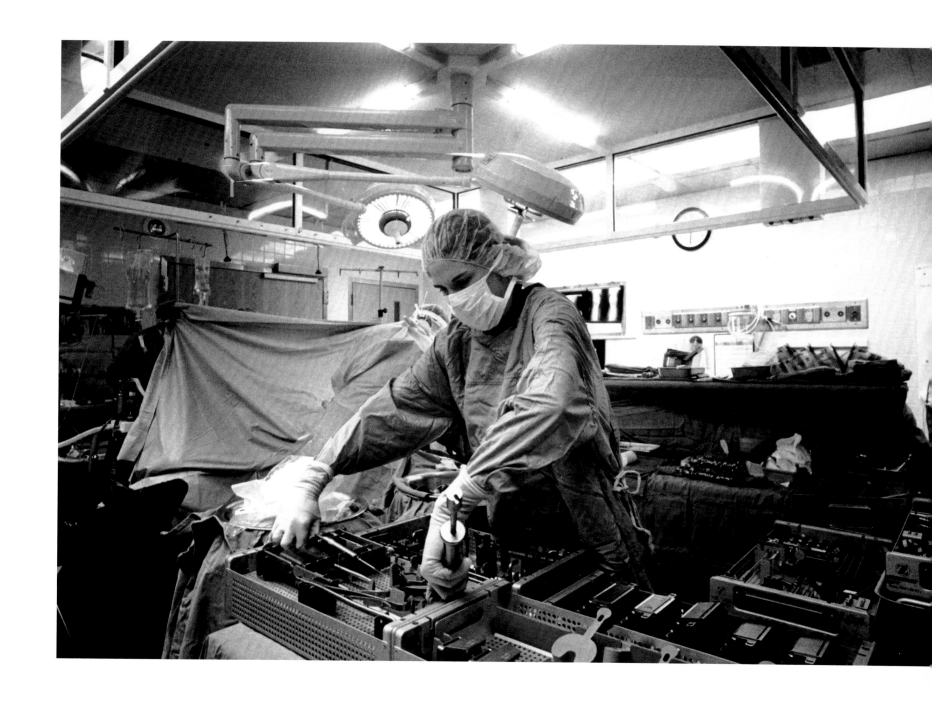

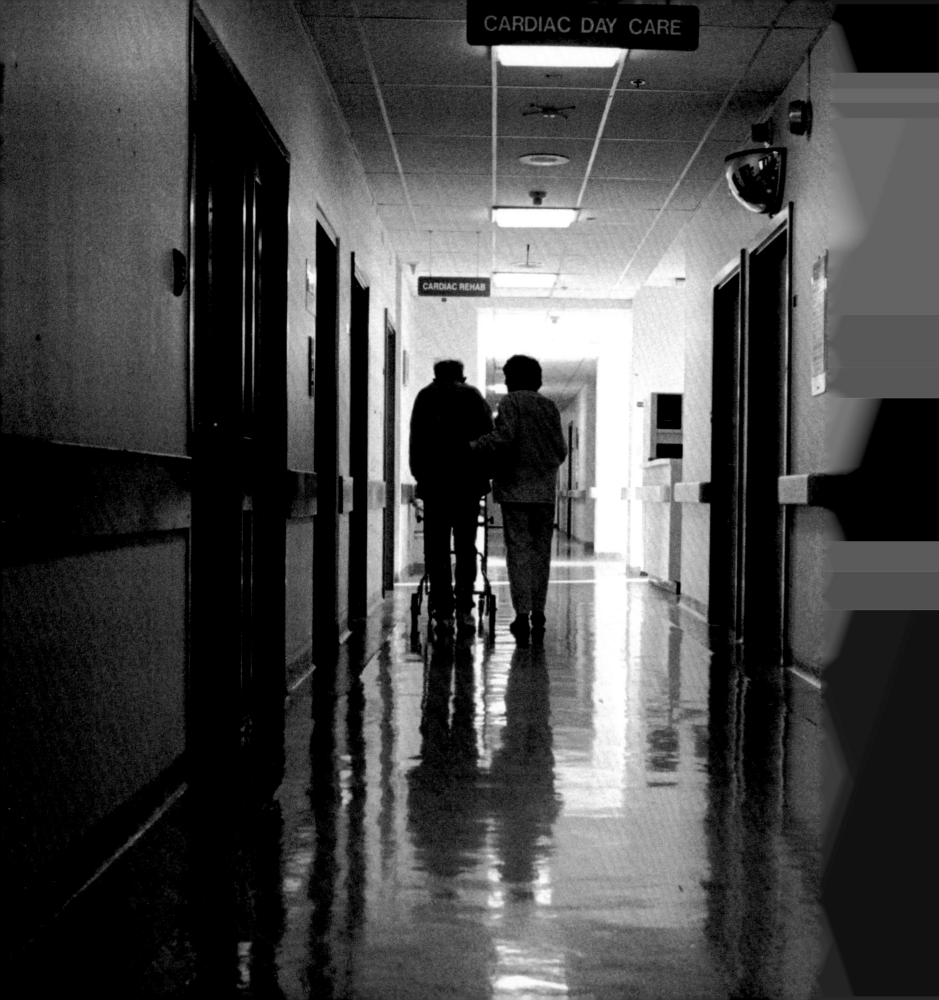

Never doubt that a small group of thoughtful,
committed citizens can change the world.
Indeed, it's the only thing that ever has.

MARGARET MEAD (1901–1978)

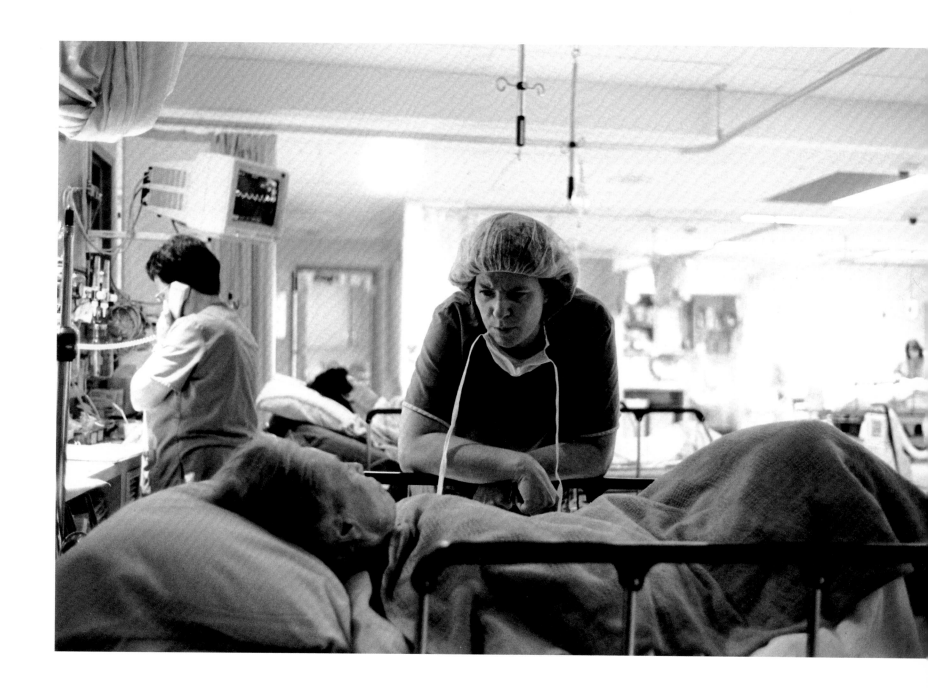

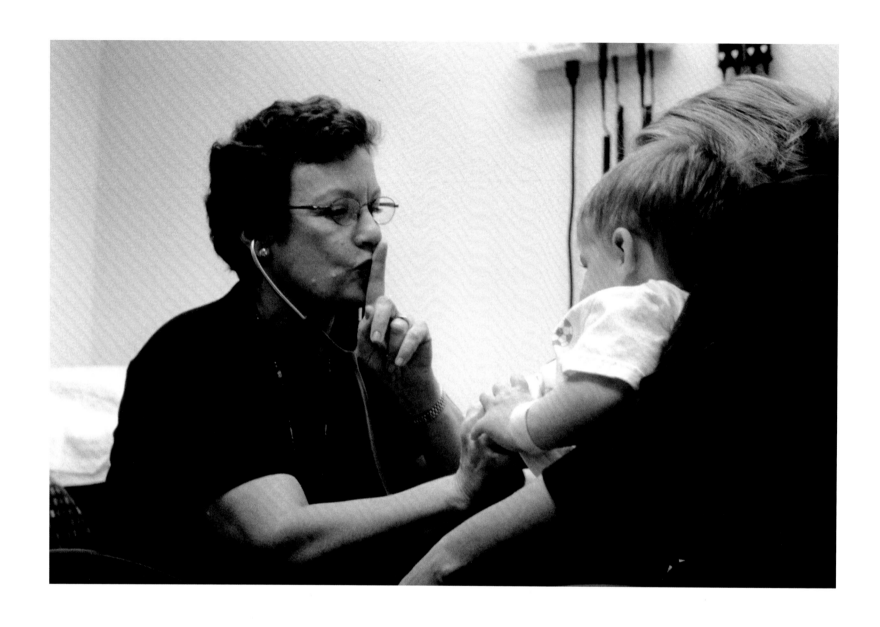

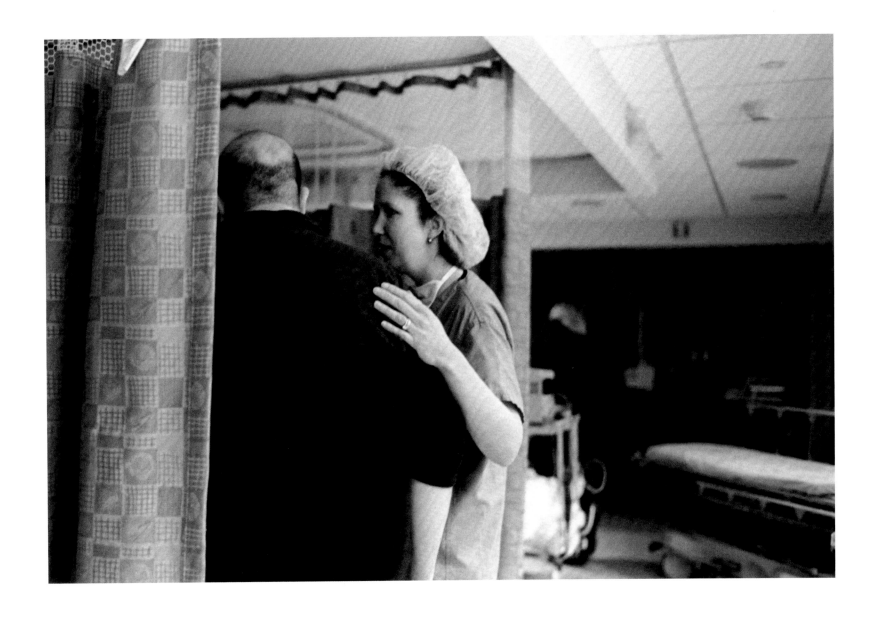

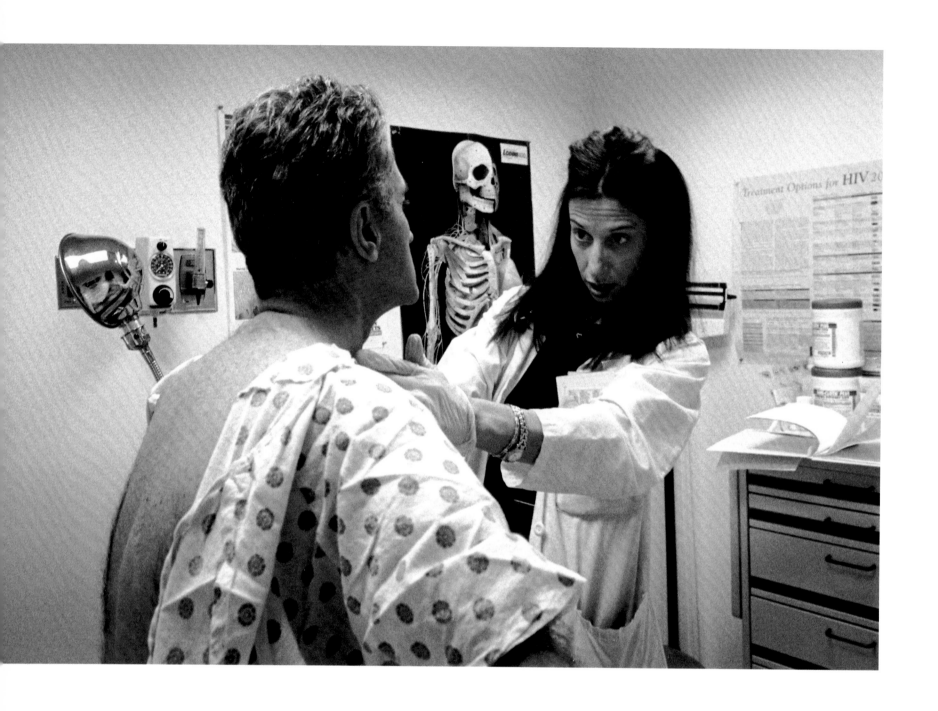

I long to speak out the intense inspiration that comes to me from the lives of strong women.

RUTH BENEDICT (1887–1948)

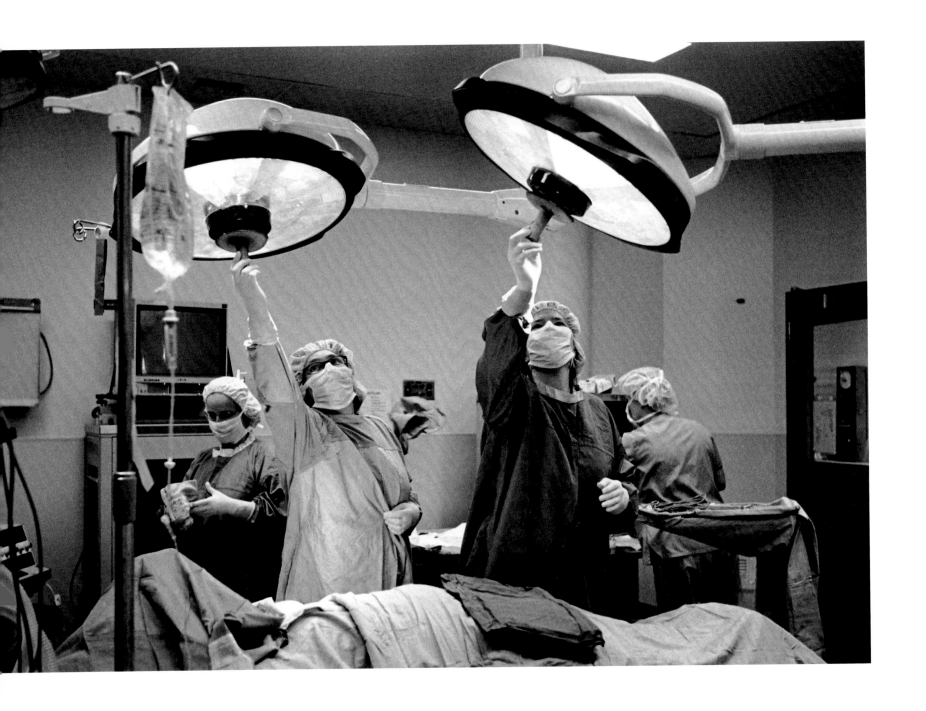

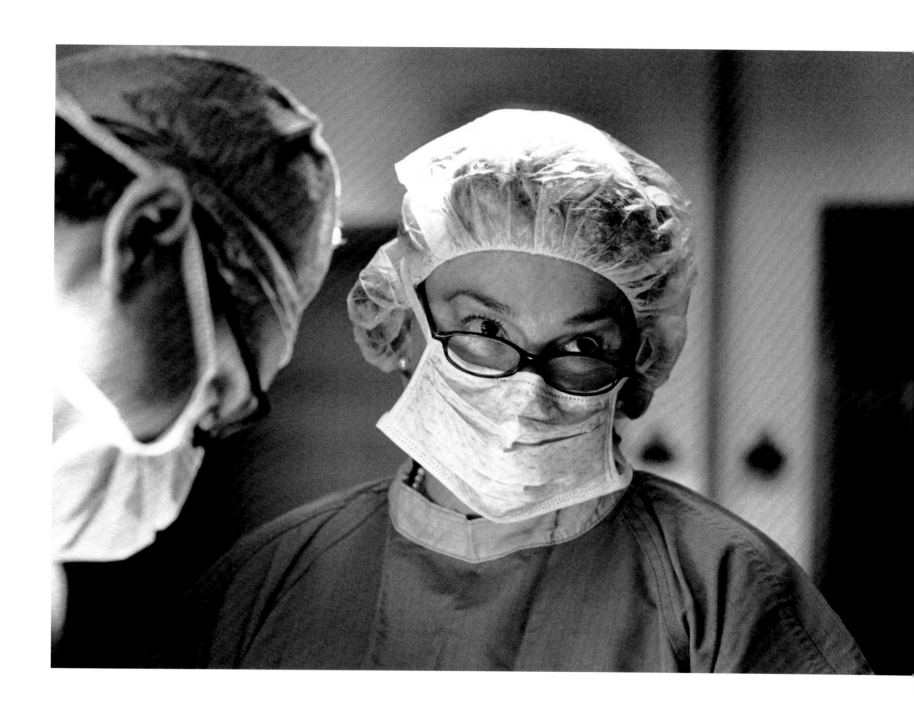

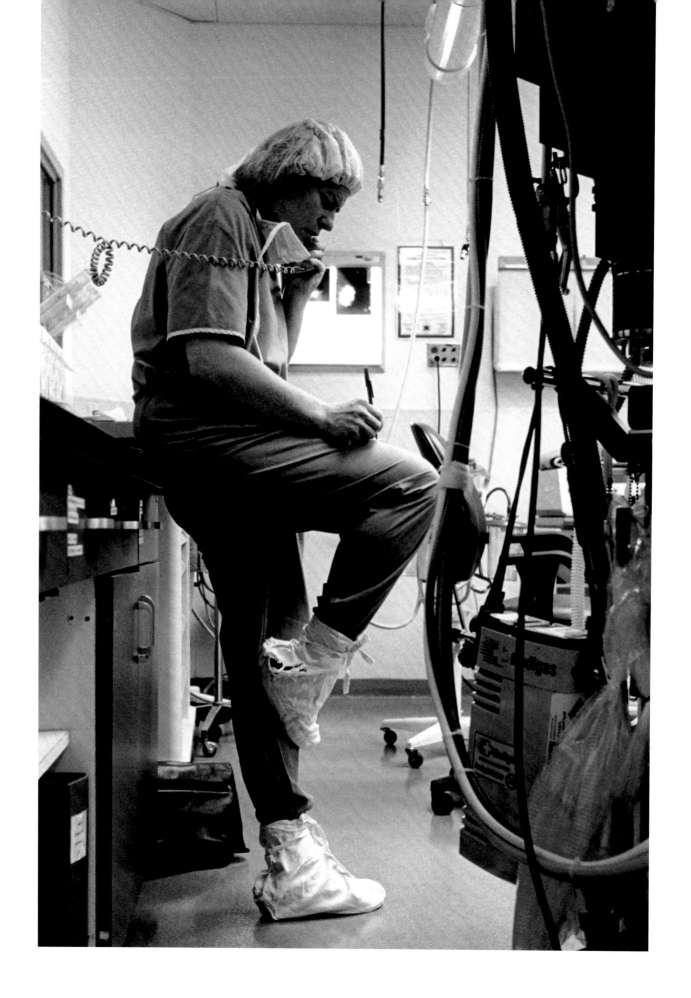

If society will not admit of women's free development,
then society must be remodeled.

ELIZABETH BLACKWELL (1821–1910)

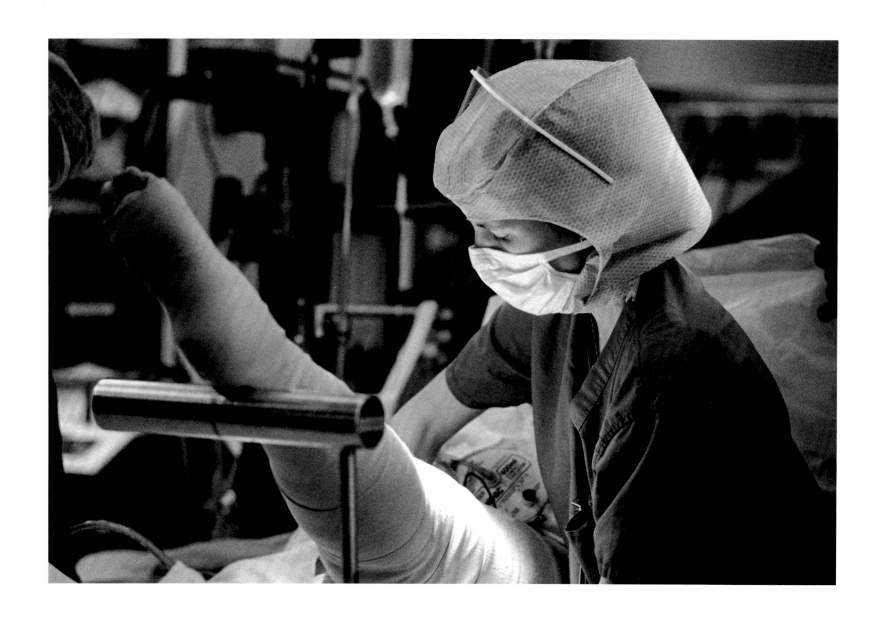

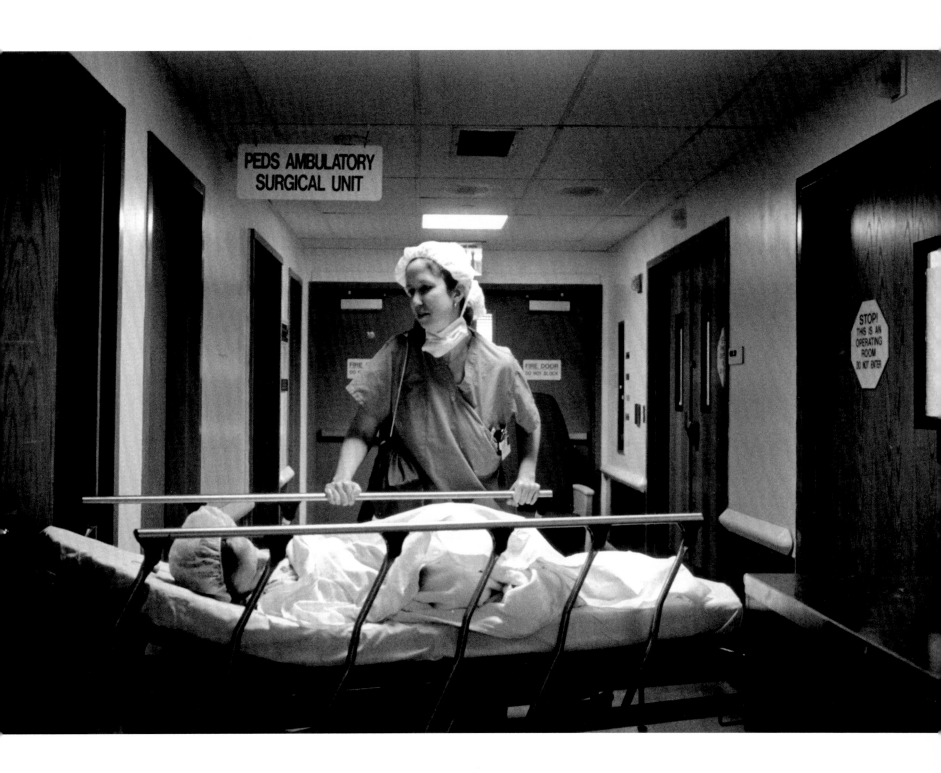

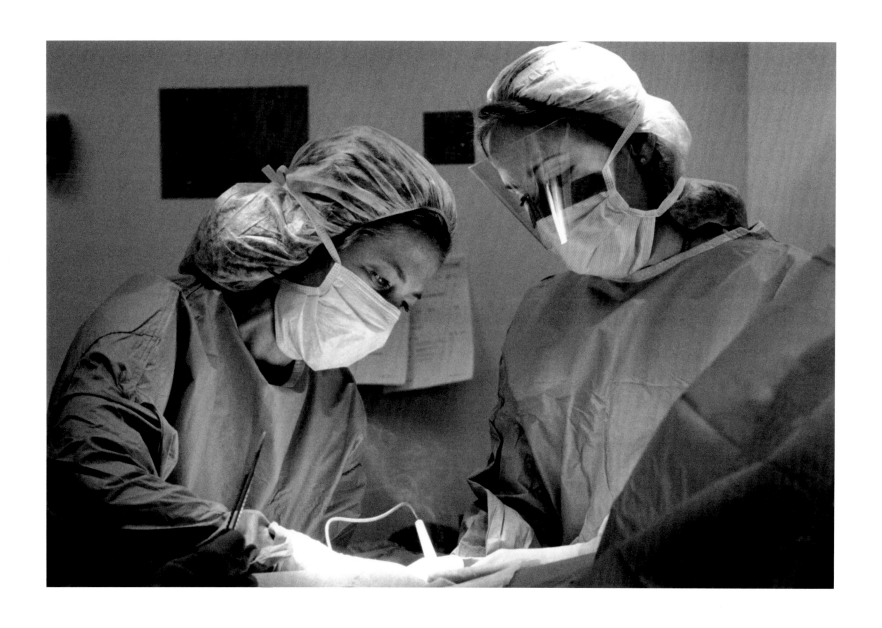

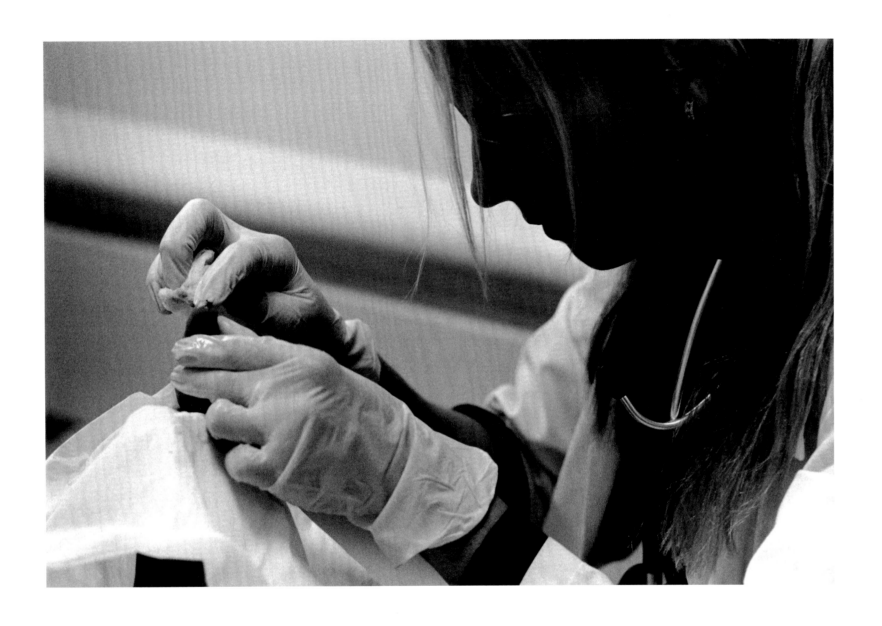

Although the world is full of suffering,

it is full also of the overcoming of it.

HELEN KELLER (1880–1968)

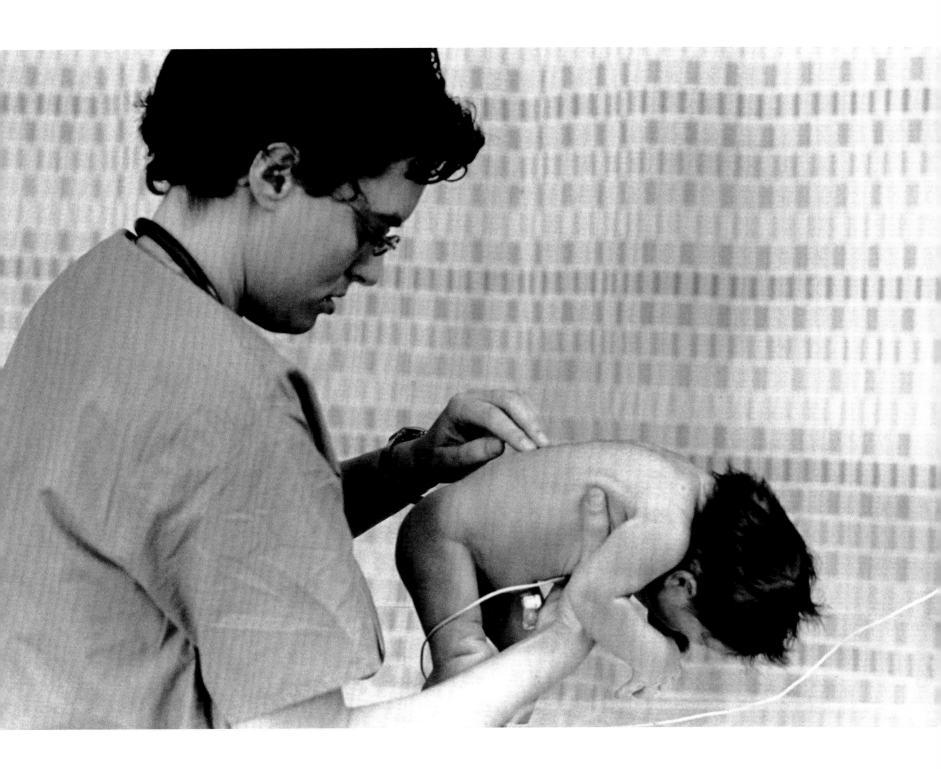

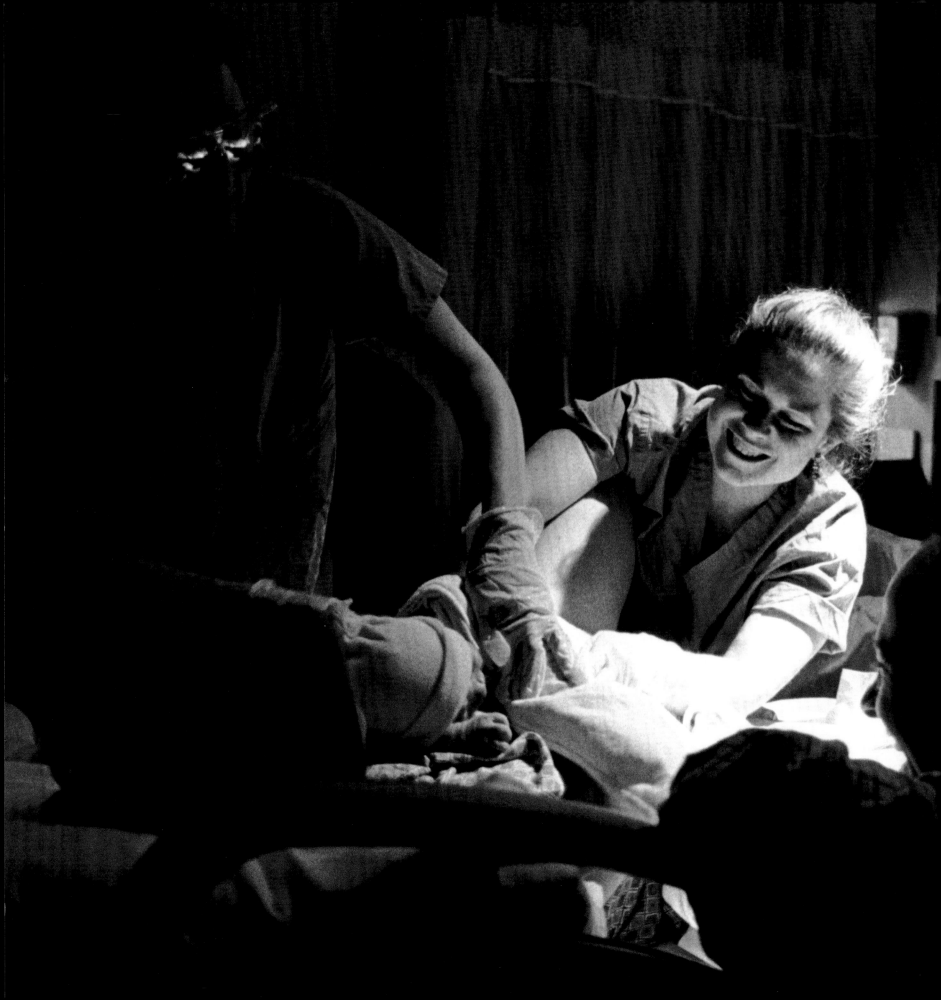

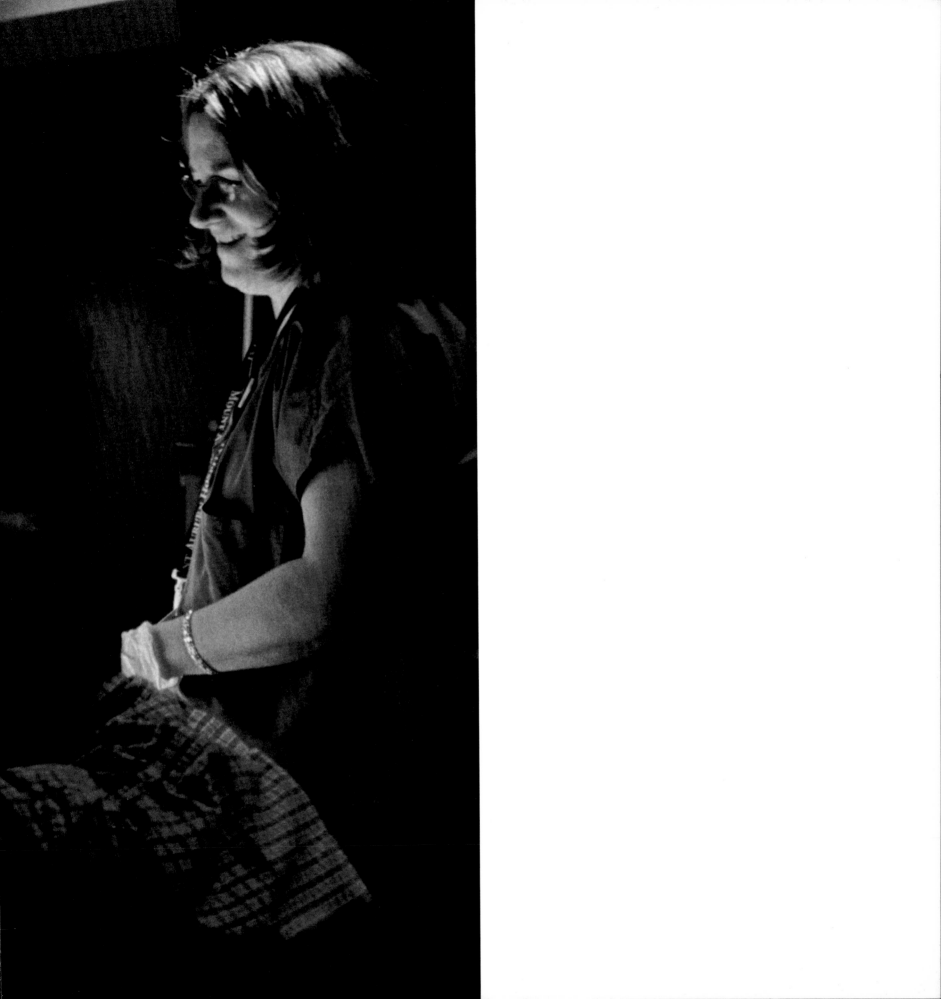

I may be compelled to face danger, but never fear it,

and while our soldiers can stand and fight,

I can stand and feed and nurse them.

CLARA BARTON (1821–1912)

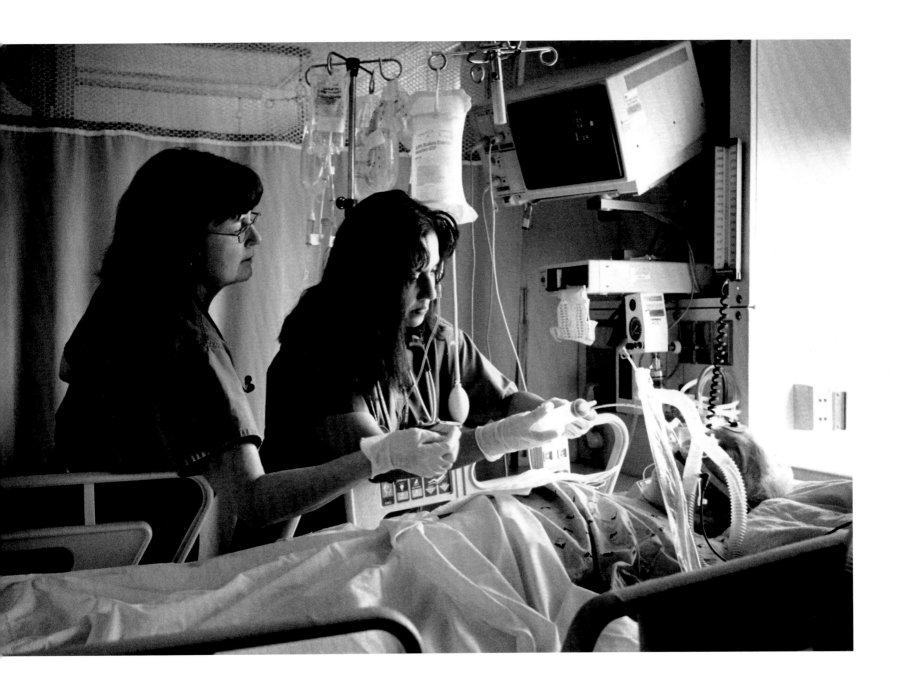

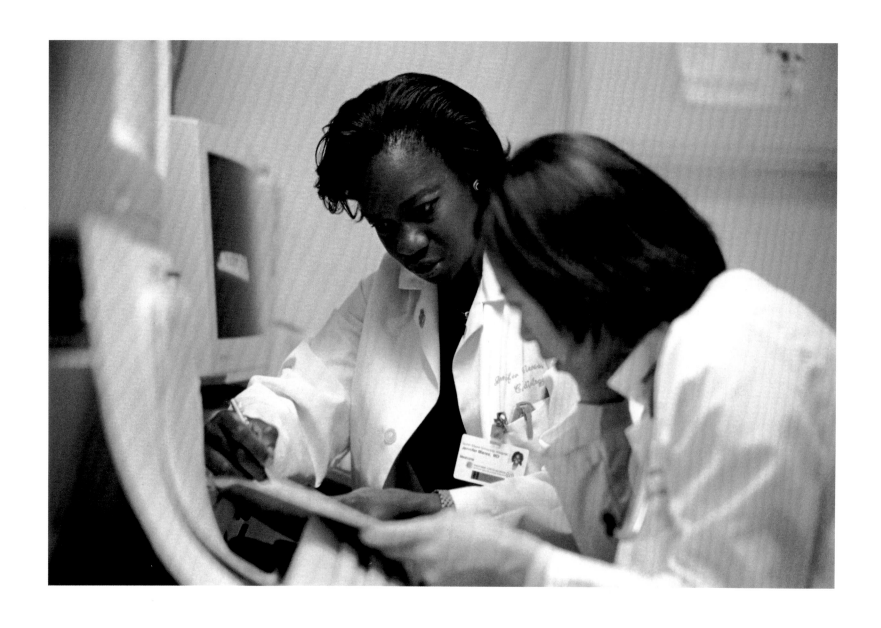

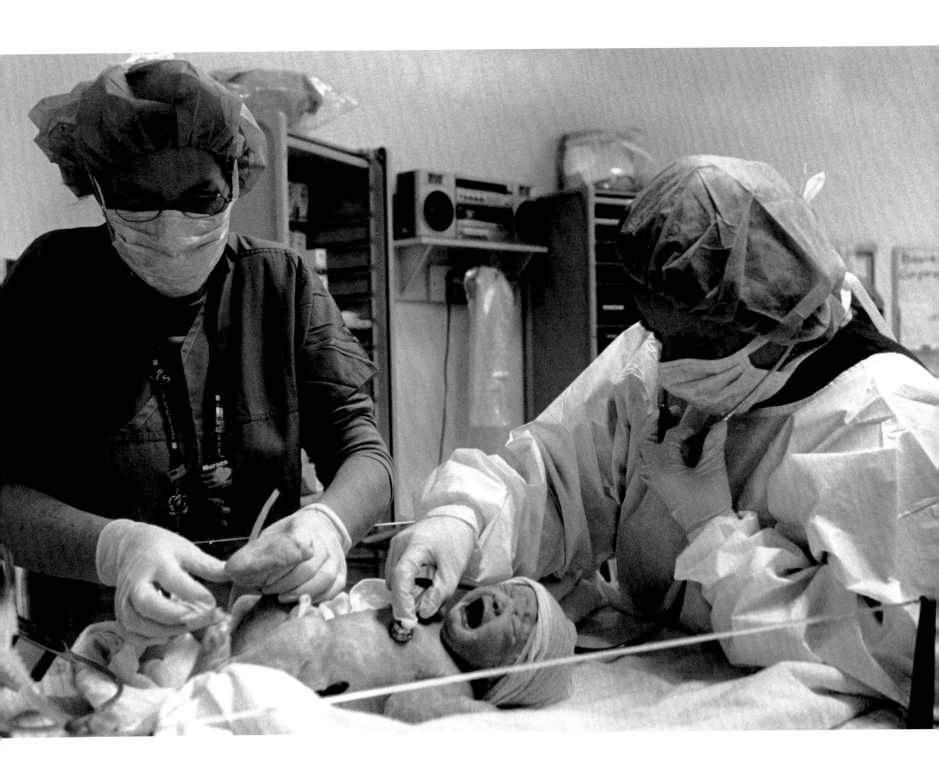

The midwife must give way to the physician.
Woman, therefore, must become physician.

ELIZABETH BLACKWELL (1821–1910)

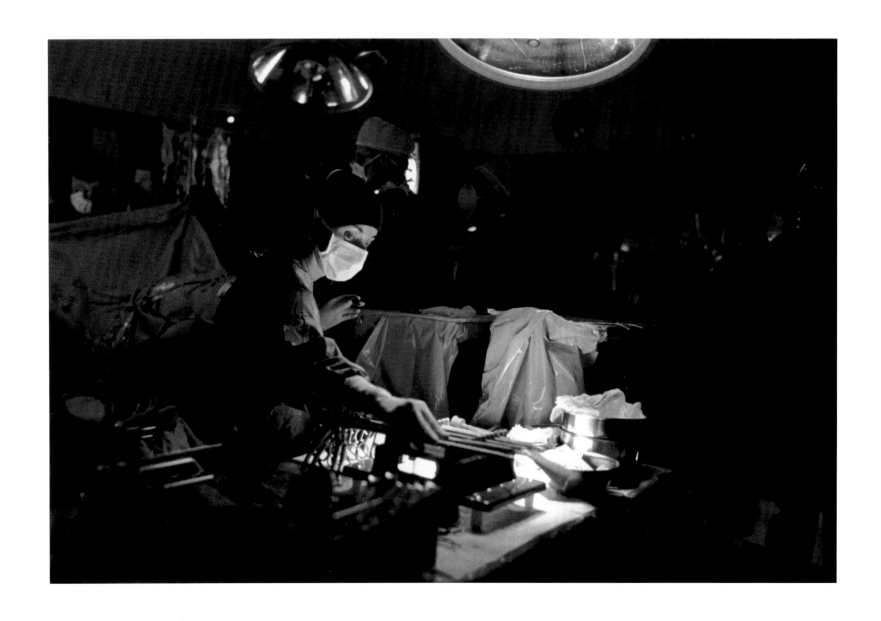

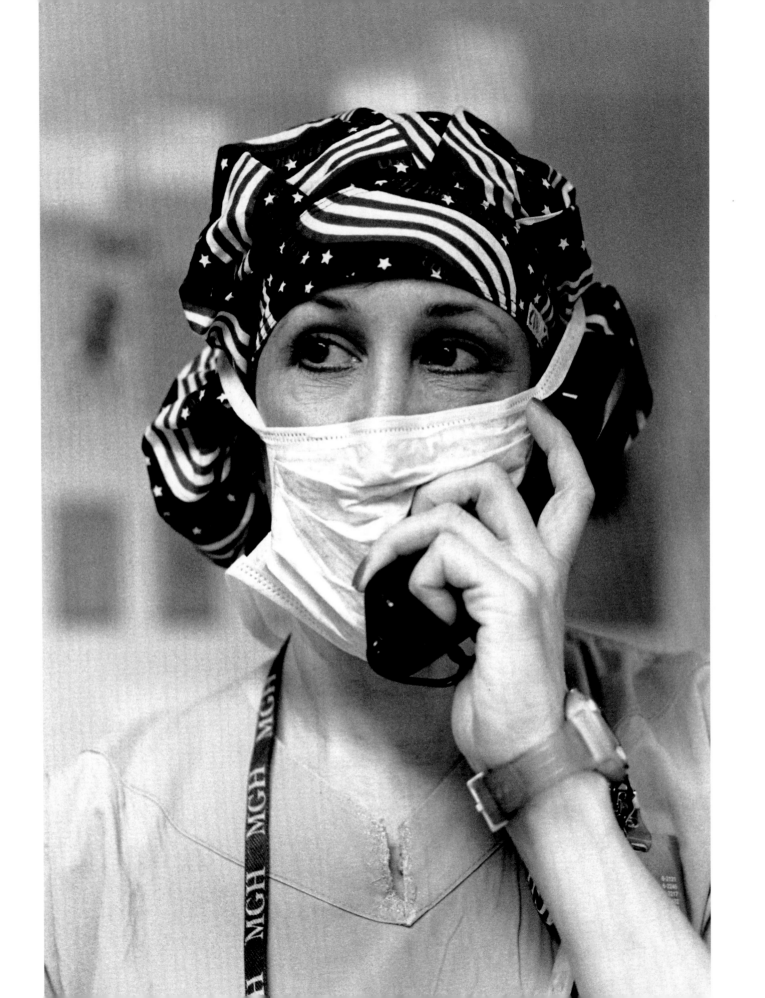

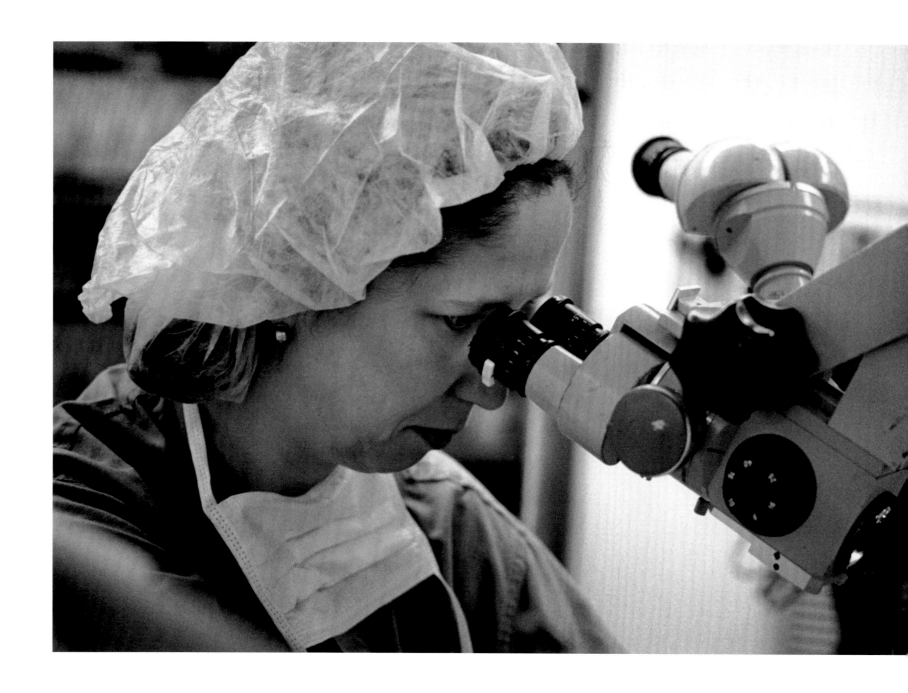

I could not, at any age, be content to take my place by the fireside and simply look on. Life was meant to be lived and curiosity must be kept alive. One must never, for whatever reason, turn his back on life.

ELEANOR ROOSEVELT (1884–1962)

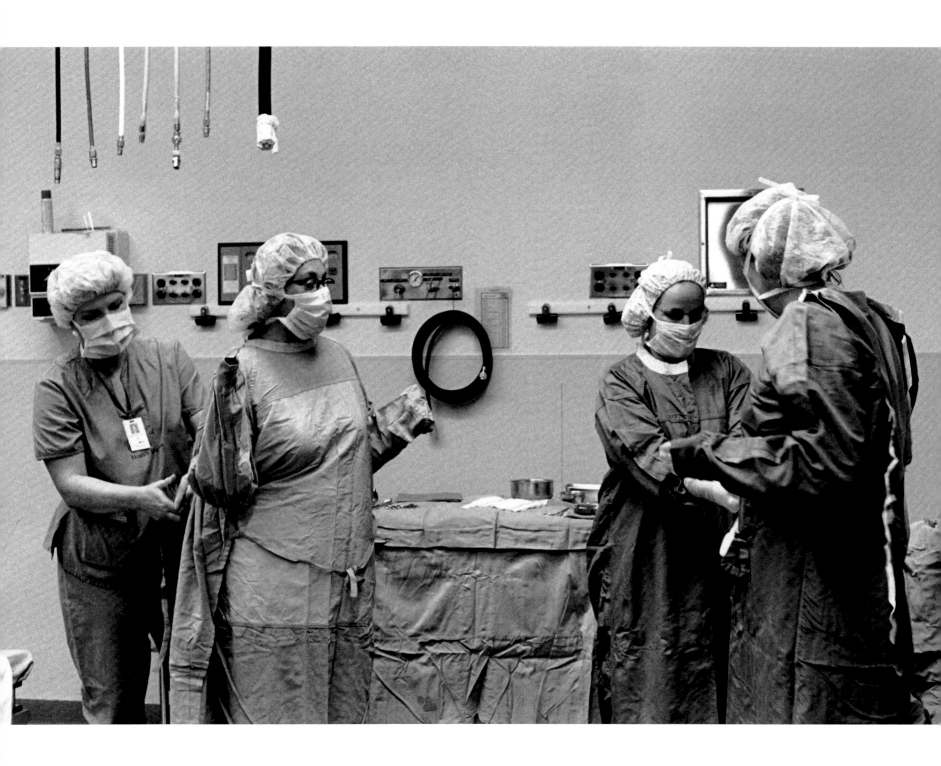

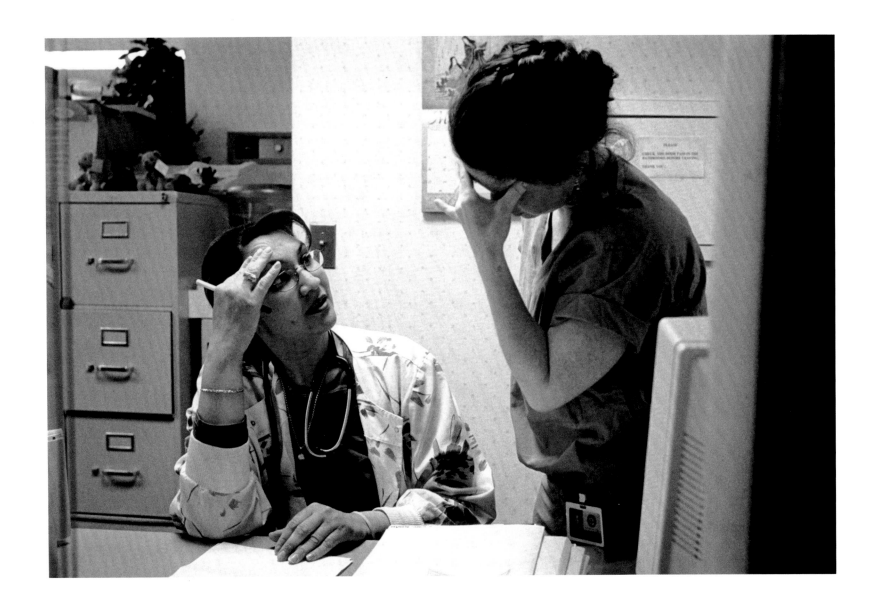

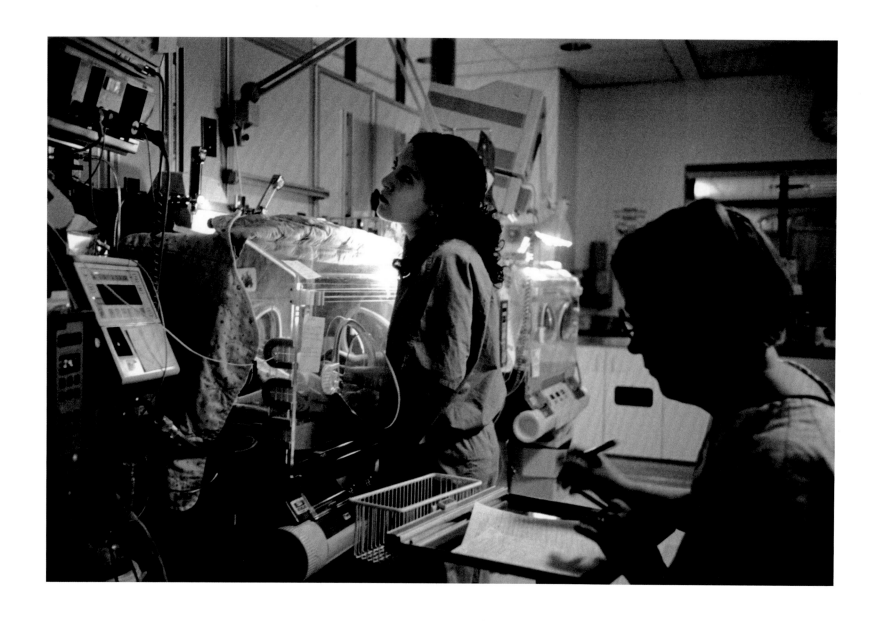

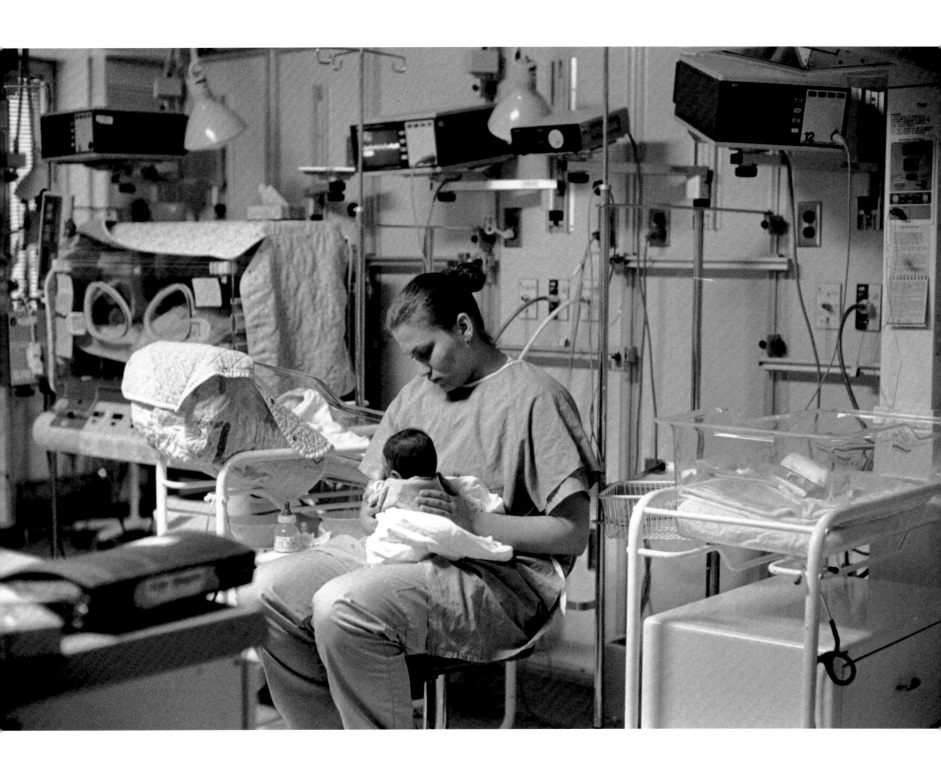

Learning is not attained by chance. It must be sought for with ardor and attended to with diligence.

ABIGAIL ADAMS (1744–1818)

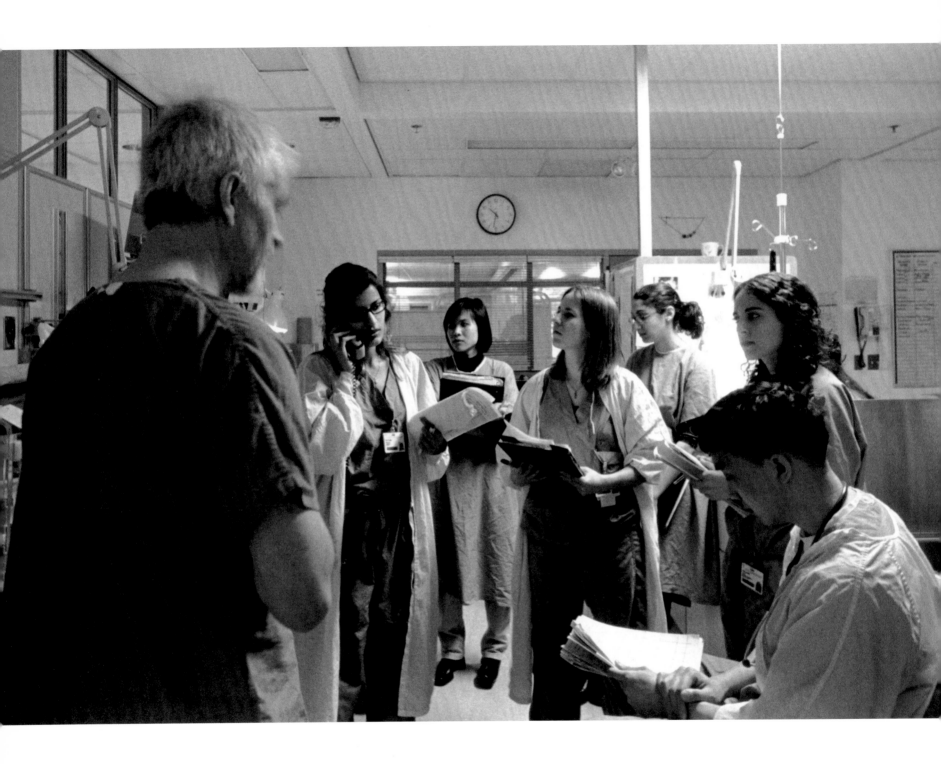

An inquiring, analytical mind; an unquenchable thirst
for new knowledge; and a heartfelt compassion for
the ailing – these are prominent traits among the
committed clinicians who have preserved
the passion for medicine.

LOIS DeBAKEY

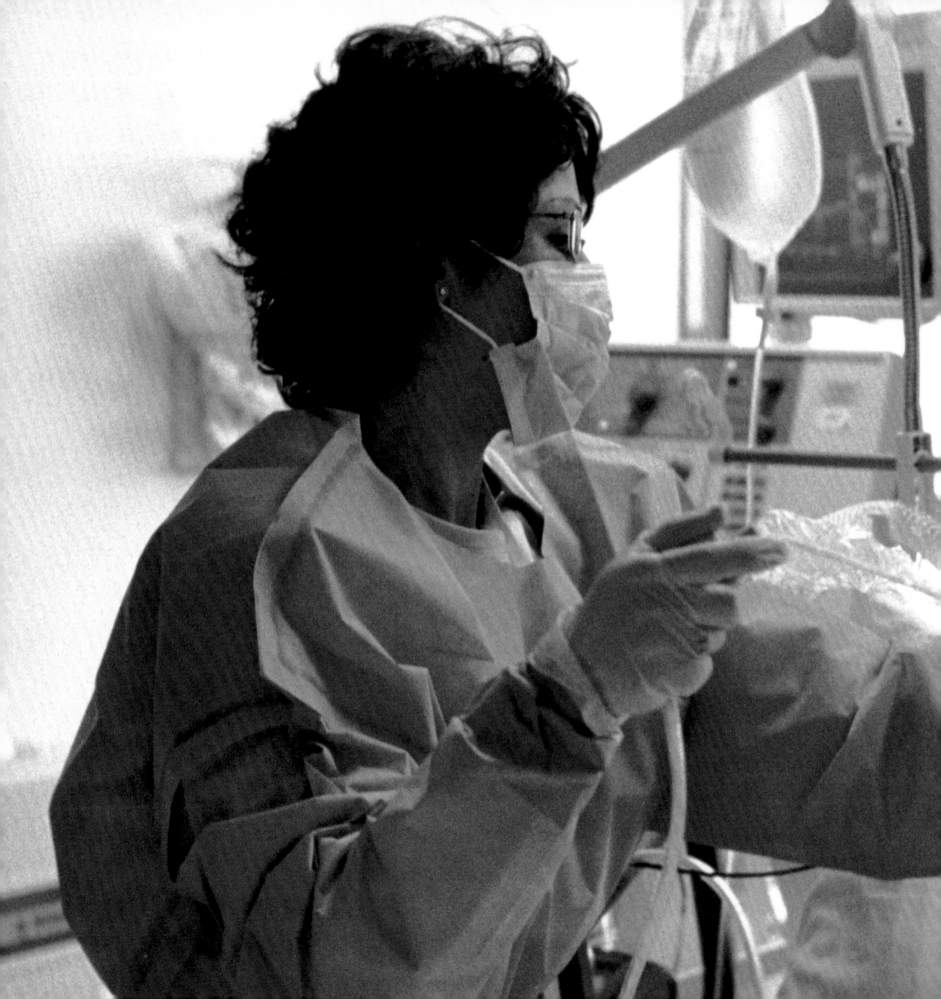

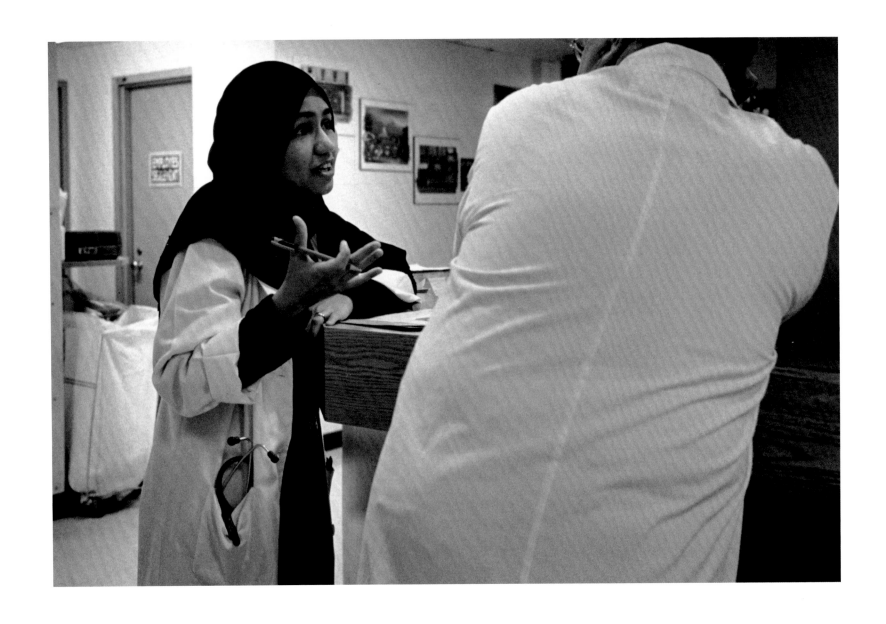

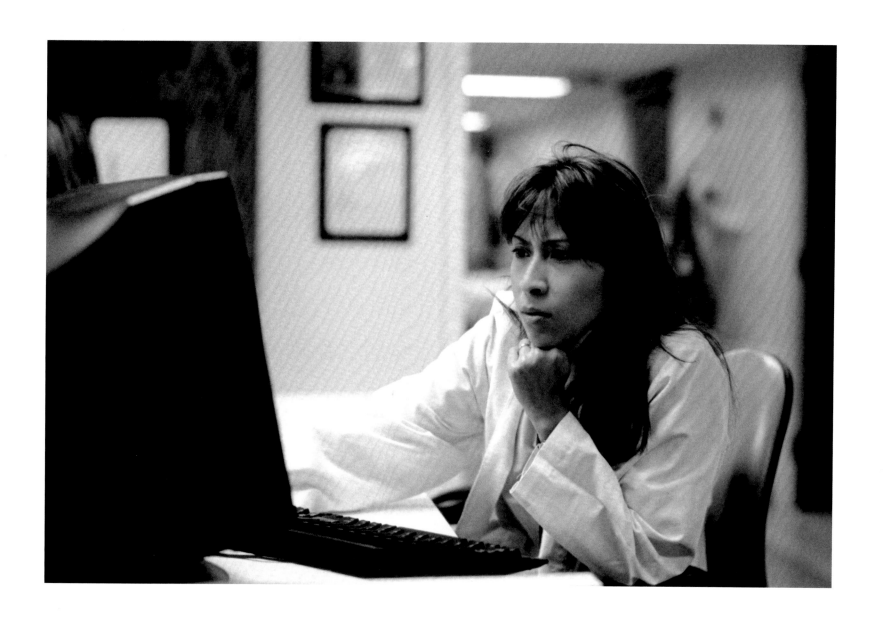

The eye that directs a needle in the delicate meshes of embroidery will equally well bisect a star with the spider web of the micrometer.

MARIA MITCHELL (1818–1889)

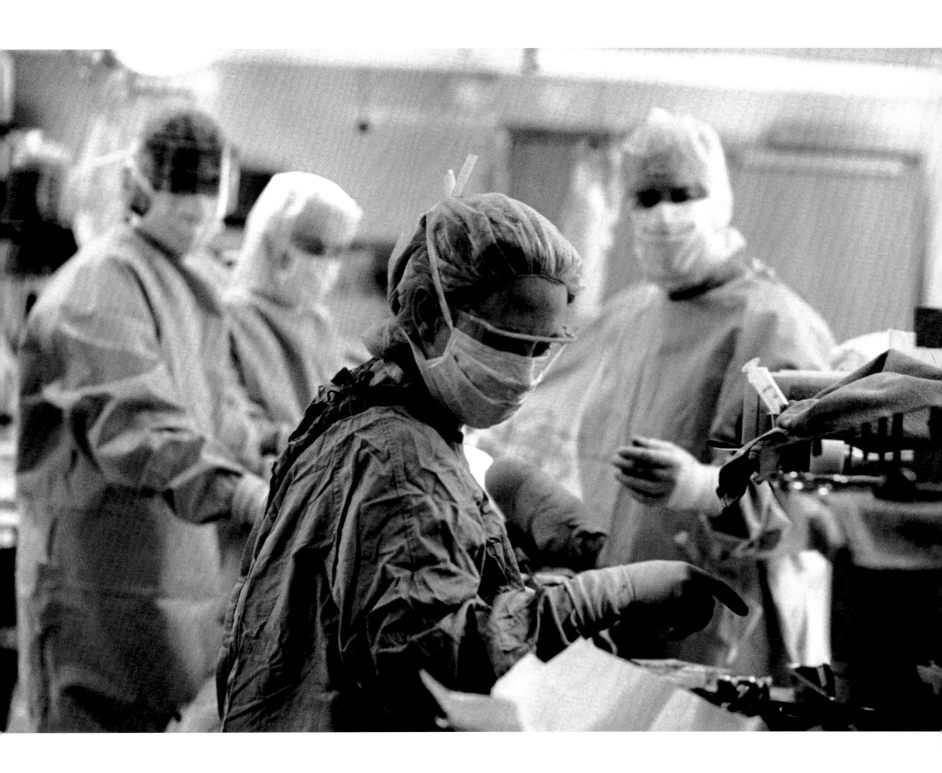

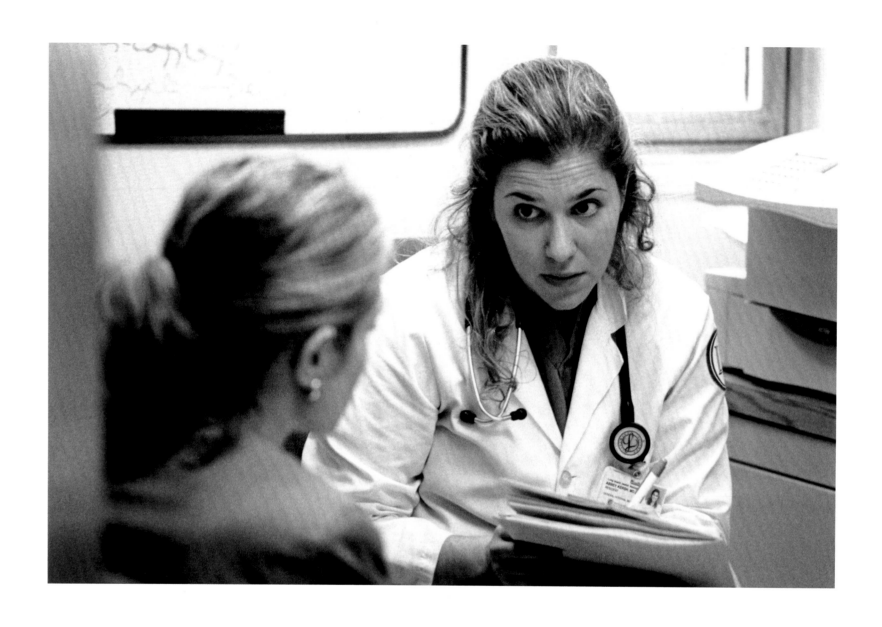

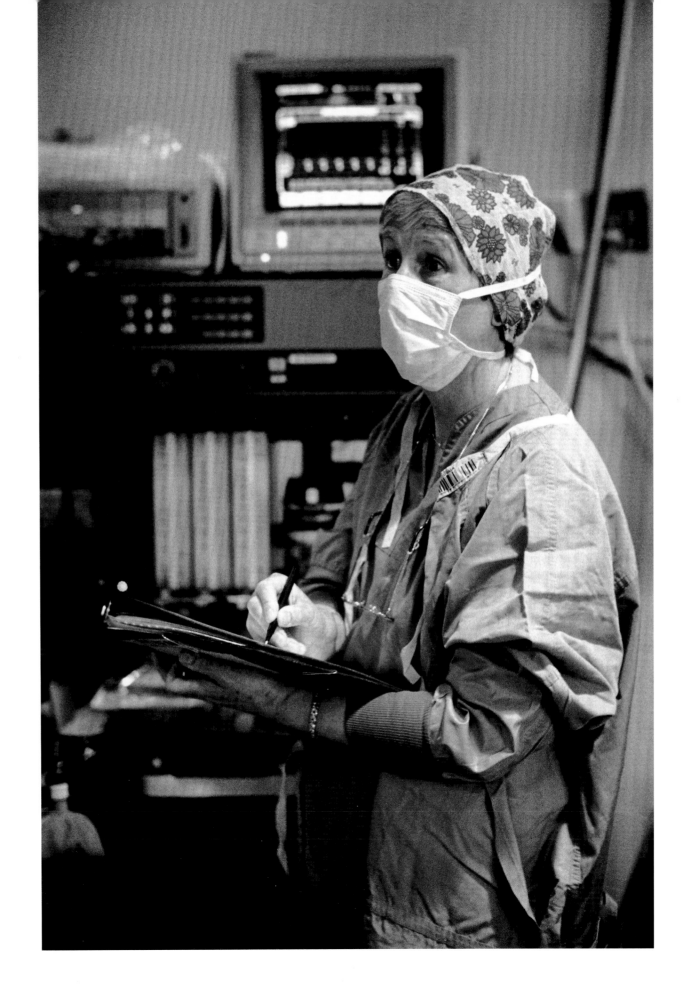

It is better to be a lion for a day

than a sheep all your life.

ELIZABETH KENNY (1886–1952)

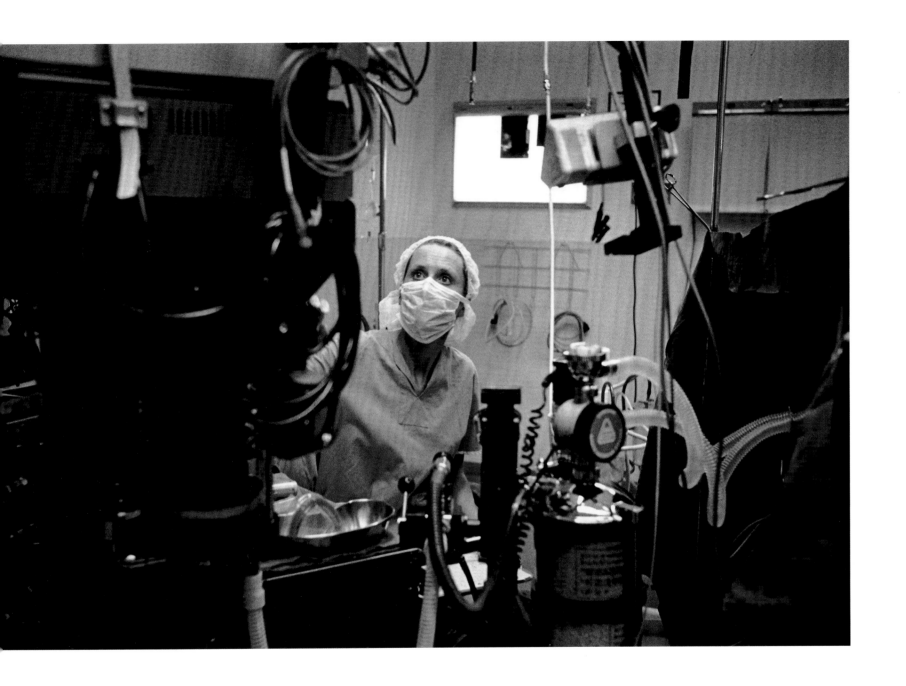

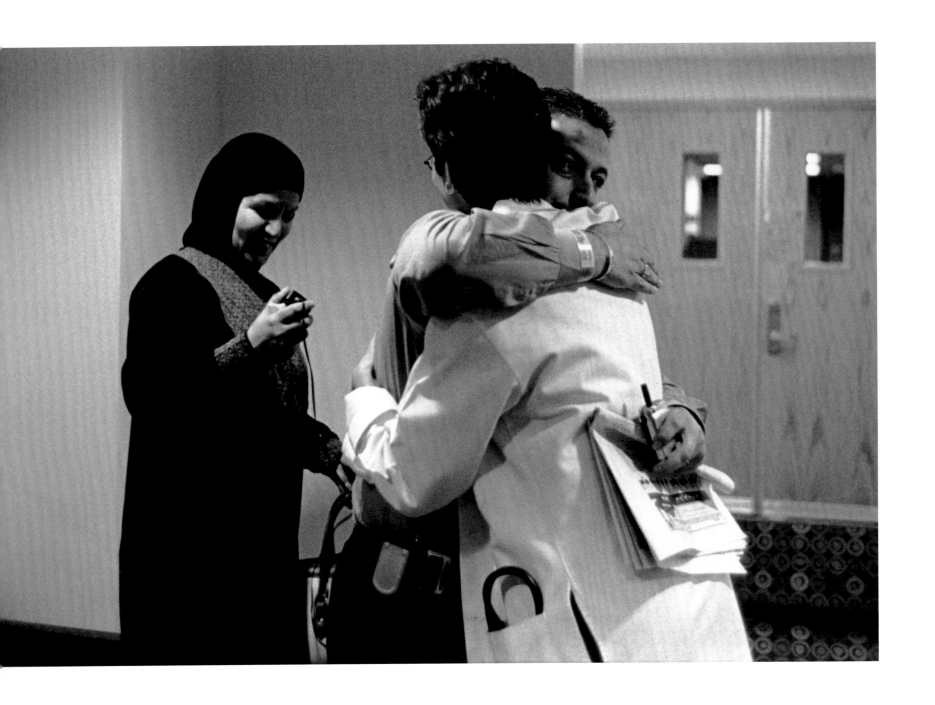

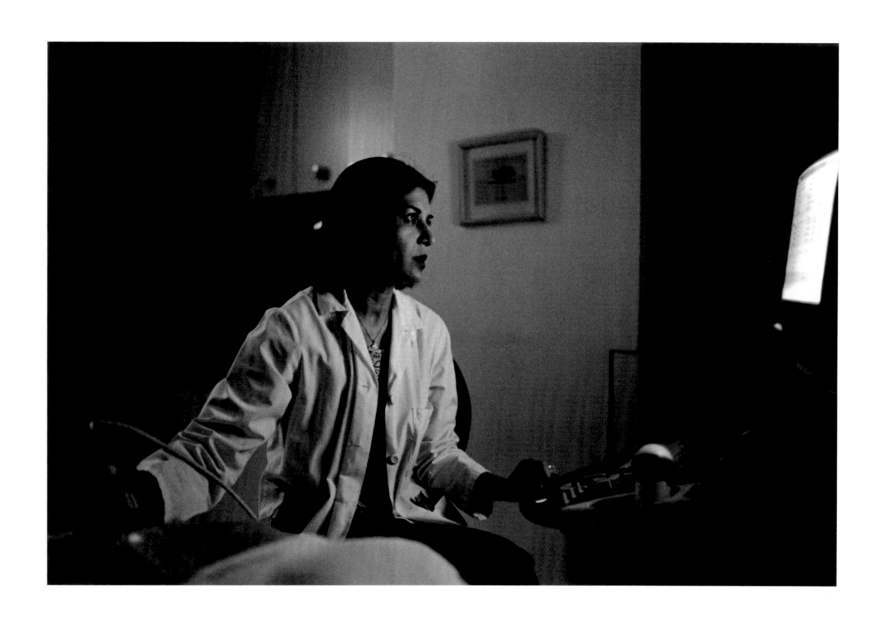

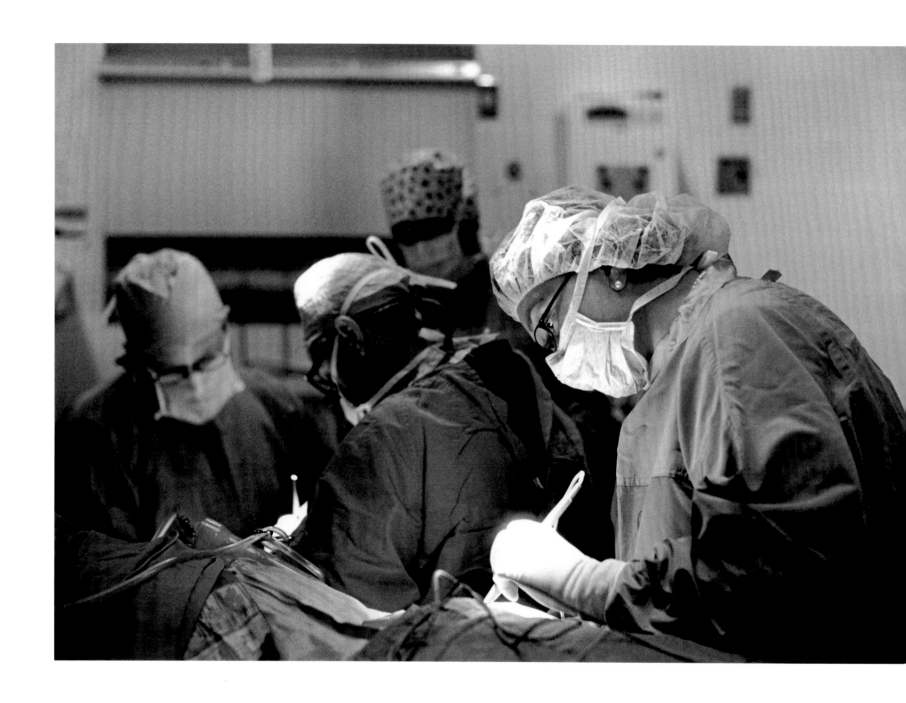

Every person is responsible for all the good within the scope of his abilities, and for no more, and none can tell whose sphere is the largest.

GAIL HAMILTON (1833–1896)

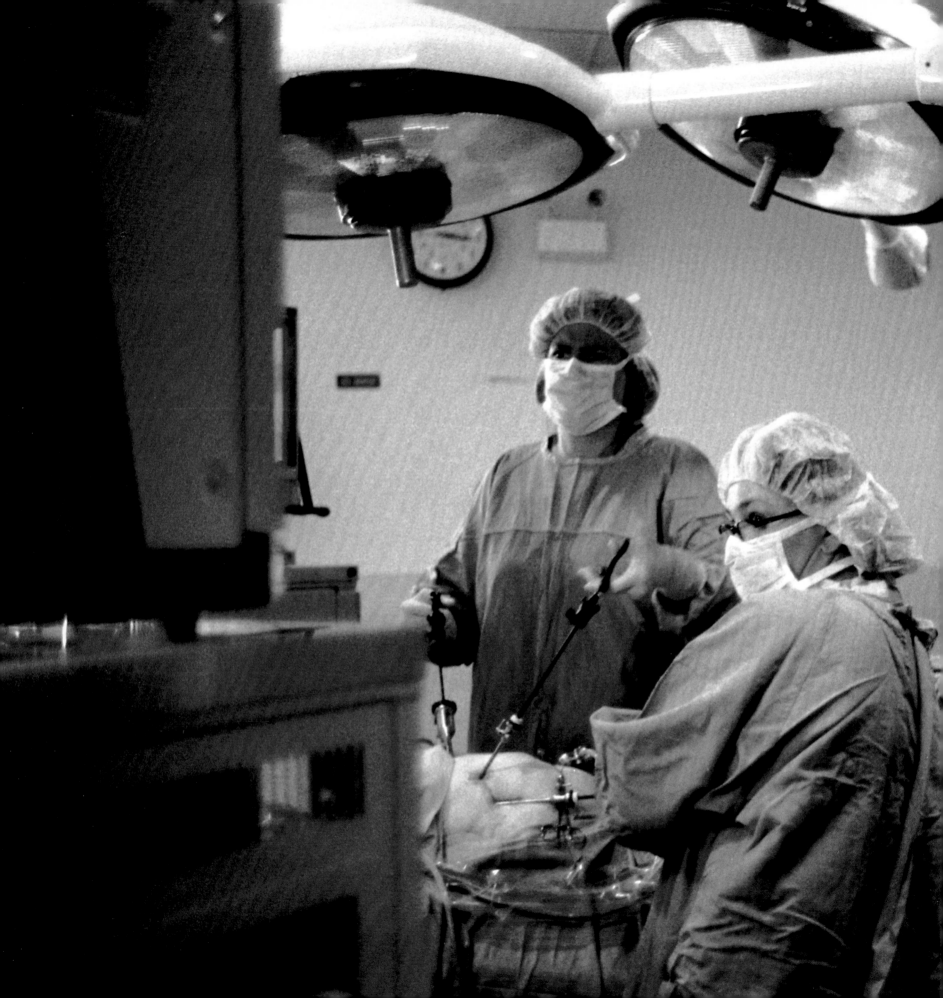

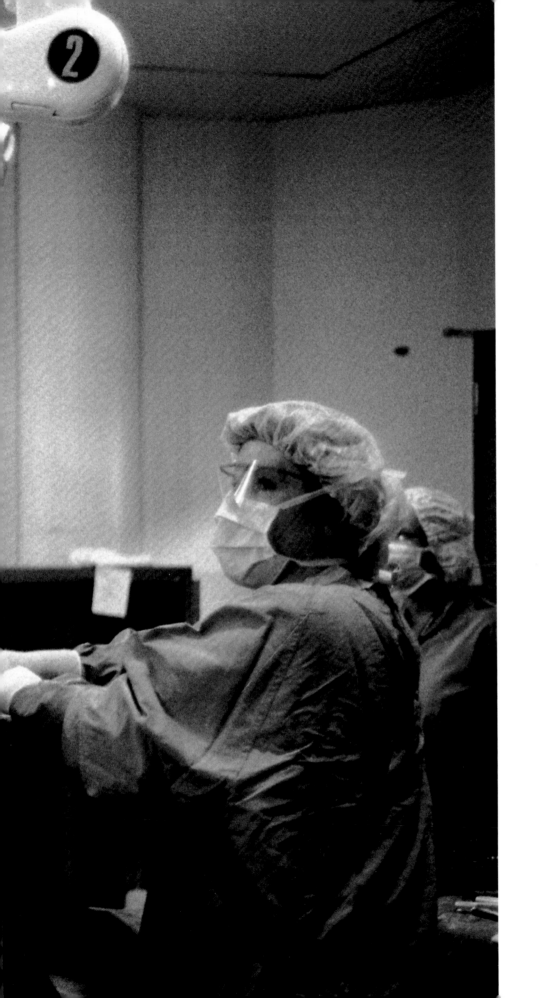

Knowledge increases in proportion to its use – that is,
the more we teach the more we learn.

HELENA PETROVNA BLAVATSKY (1831–1891)

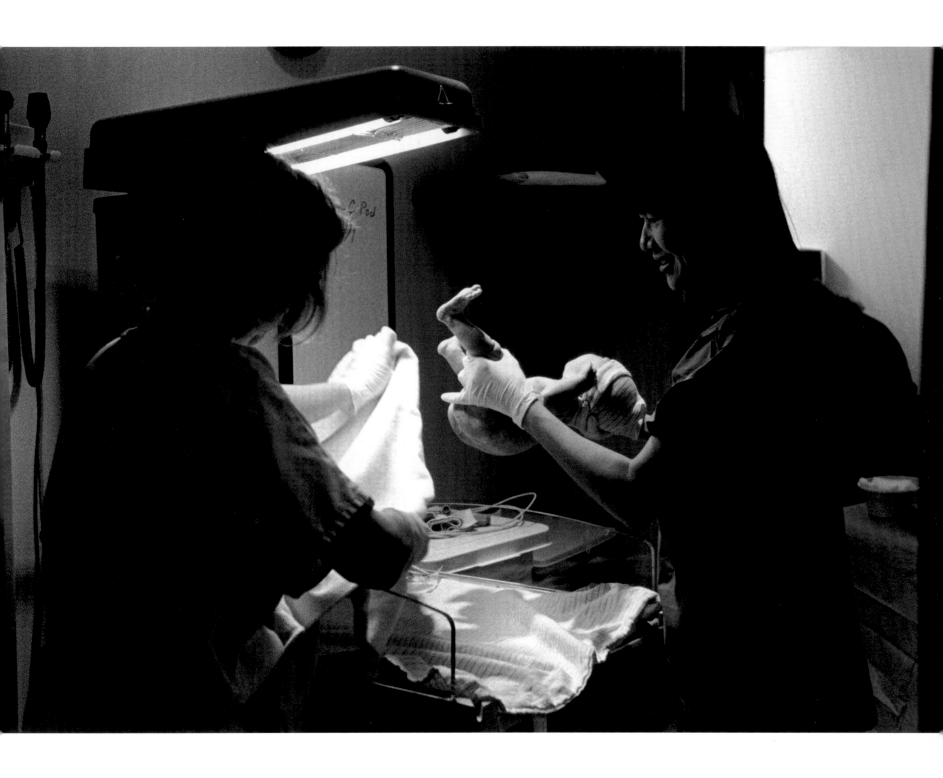

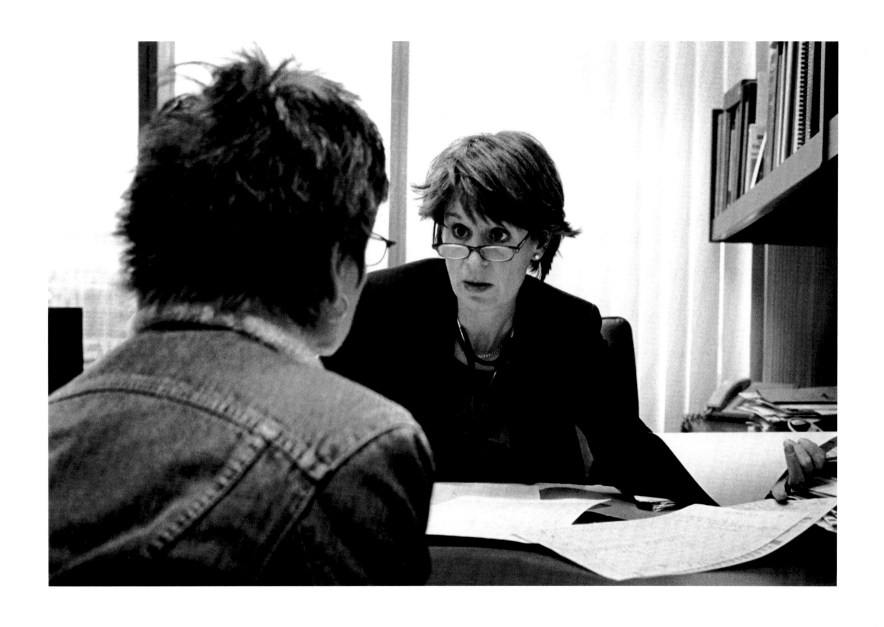

Let women be provided with living strength of
their own. Let them have the means to attack
the world and wrest from it their own subsistence,
and their dependence will be abolished –
that of man also.

SIMONE DE BEAUVOIR (1908–1986)

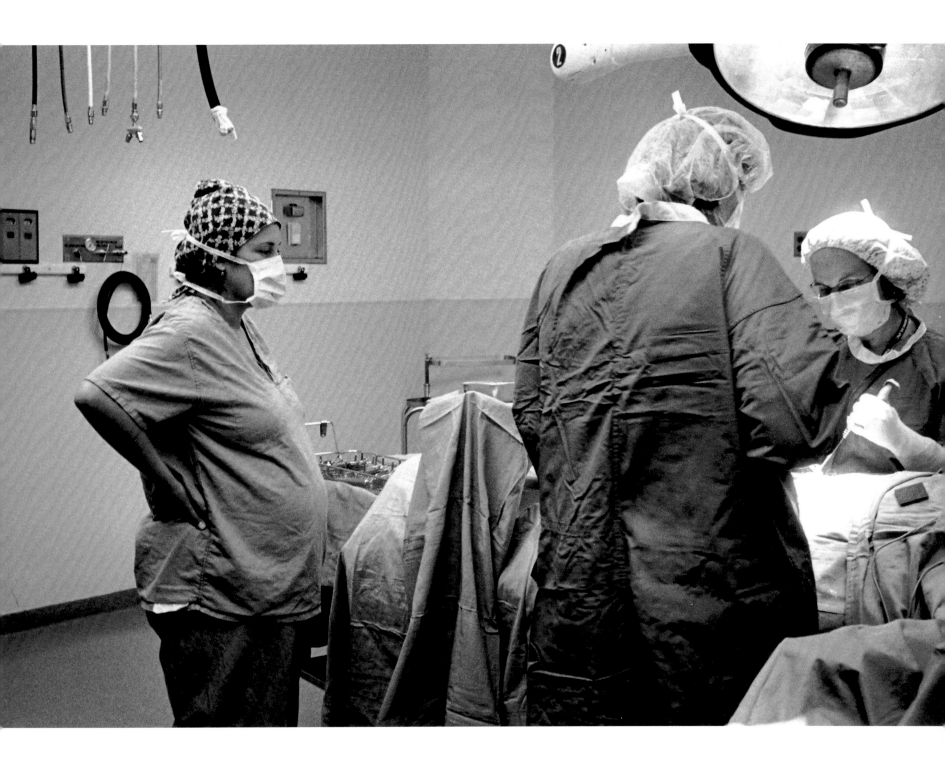

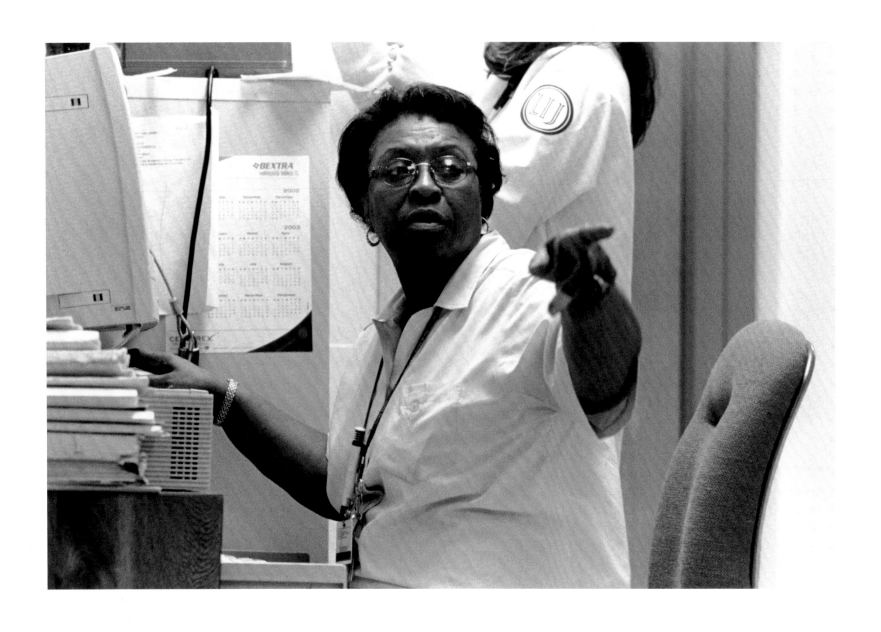

INDEX